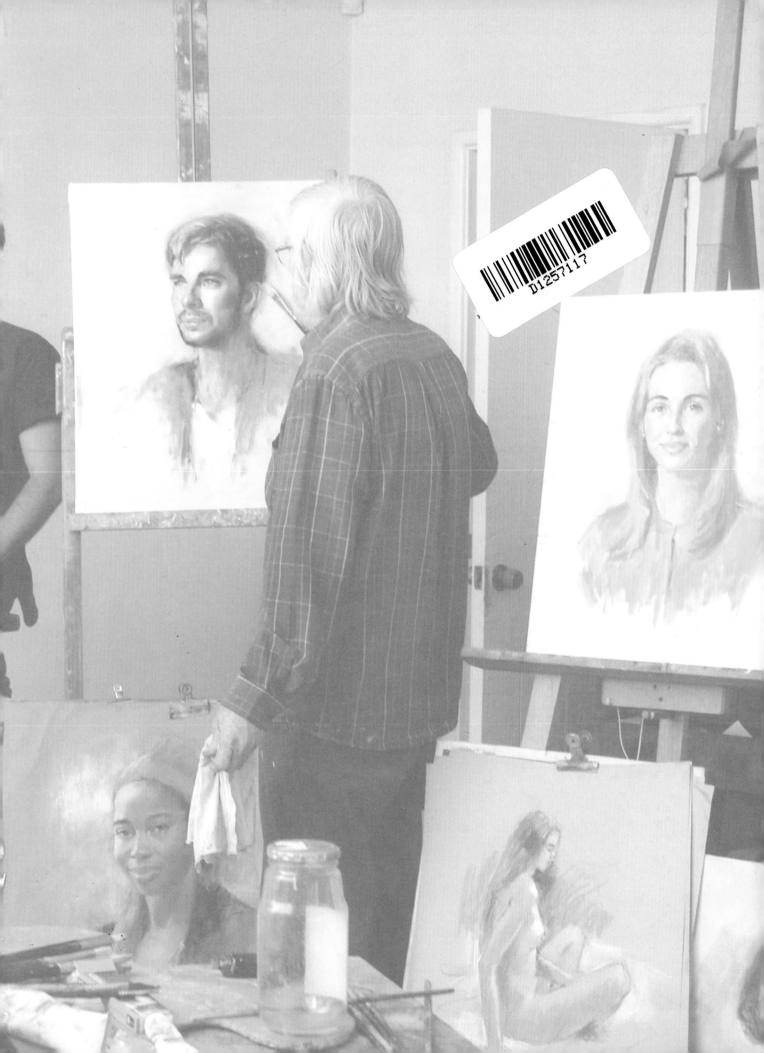

PAINTING PORTRAITS *in* OILS

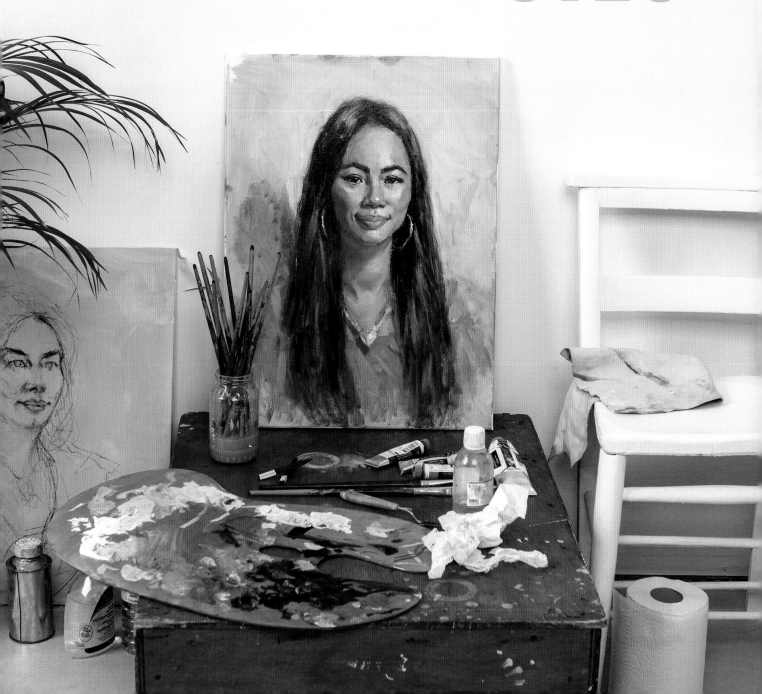

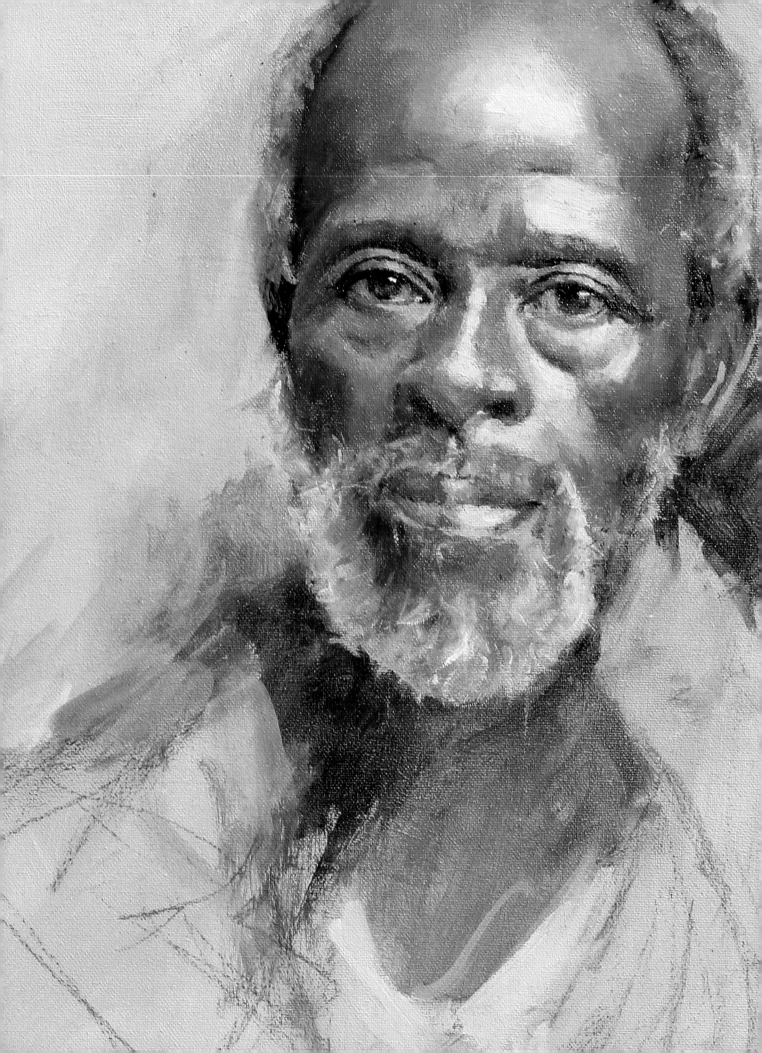

PAINTING PORTRAITS in OILS

CAPTURING CHARACTER FROM LIFE

ROB WAREING

5❀ SEARCH PRESS

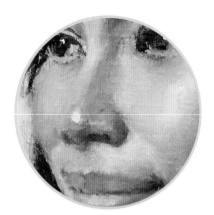

Dedication

To my hard-working wife
and our ever-growing family,
without whom this would not
have been possible.

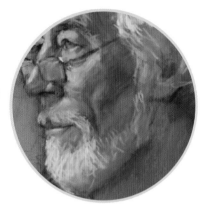

Acknowledgements

Thanks to the models who have
sat for me, and to Edward Ralph
from Search Press, whose
guidance has made what
seemed impossible a reality.

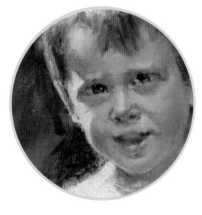

First published in 2021 ISBN: 978-1-78221-796-1
ebook ISBN: 978-1-78126-753-0

Search Press Limited, Wellwood, North Farm Road, Tunbridge
Wells, Kent TN2 3DR

Illustrations and text copyright © Rob Wareing 2021

Photographs by Mark Davison at Search Press Studios.
Additional photographs author's own.

Photographs and design copyright © Search Press Ltd 2021

Publishers' note
The Publishers and author can accept no responsibility for
any consequences arising from the information, advice or
instructions given in this publication. Printed in China.

Suppliers
If you have difficulty in obtaining any of the materials and
equipment mentioned in this book, then please visit the
Search Press website for details of suppliers:
www.searchpress.com

You are invited to visit the author's website at:
www.robwareing.com

CONTENTS

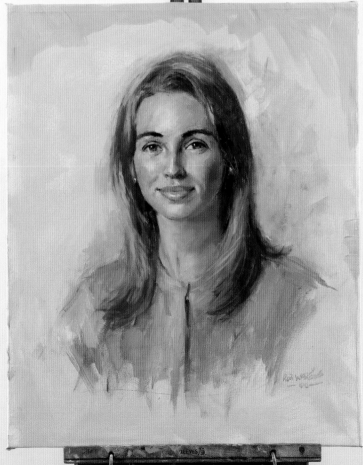

Foreword

BY TINUS HORN

Some successful artists guard their expertise as though they're afraid that sharing it will dilute the value of their own work. Rob Wareing knows instinctively that the opposite is true; a generosity of spirit is essential to a fulfilling career.

Rob is a born teacher. No one walks away from his workshops and demos without having learnt something of value that will have a positive impact on their own work. His teachings are built on basic tenets that haven't changed much, if at all, since the 1870s, when the Impressionists turned the art of painting on its head: Draw and paint from life; observe carefully; stop when you're done.

My paraphrase doesn't do these simple rules justice. And knowing the rules won't turn you into an instant sensation – when you're starting out, they merely deepen the mystery. How do you go about drawing from life? What does 'observe carefully' mean in this context? How do you know when a drawing or painting is done?

That's where an expert, who has honed his craft throughout a long and distinguished career, comes in. With this book, Rob aims to provide the answers to those and many other questions that face anyone who aims to become an accomplished portrait artist.

Rob once said in my company that all artists are self-taught, in the sense that no amount of teaching will result in progress unless the artist puts the theory into practice and makes his or her own discoveries along the way. Teachers are guides, which is how Rob wants this book to be seen.

He has created a road map, which is a tremendously useful tool – provided you get behind the wheel and drive. Art isn't a kind of magic bestowed upon 'gifted' or 'talented' individuals. The magic happens when you commit to your craft and put in the hours at the easel.

Thirty-two years ago, a single afternoon watching Rob at work, producing pastel portrait sketches in the foyer of the Margate Hotel on the southern coast of South Africa, changed the course of my life. I was an instant convert to the art of portraiture, and it has lost none of its allure.

It wasn't Rob's technical prowess alone that won me over. I asked him for advice, which he shared readily, and his passion for and commitment to his chosen pursuit sealed the deal. This is what the best teachers do: they share, encourage and inspire. Portrait artists at every level will benefit from his insight and expertise.

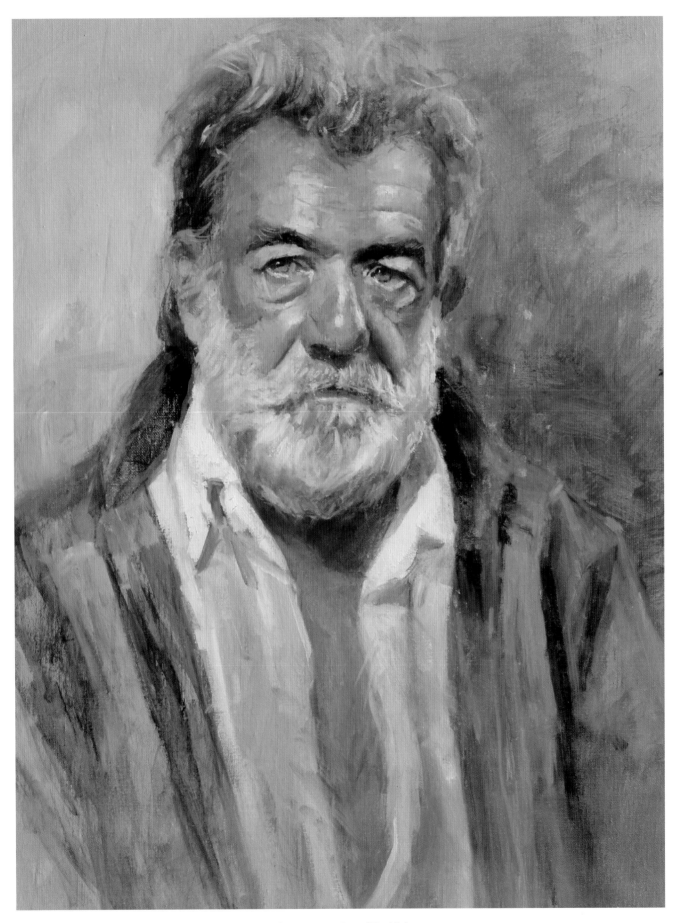

Stewart 56 x 71cm (22 x 28in)

Introduction

There are many different ways of painting a portrait in oils. In this book I will focus on a direct approach, where the goal is to complete the portrait *alla prima*. This approach has been used by artists for hundreds of years, leaving us with many wonderful masterpieces to enjoy.

Painting a portrait alla prima shares many similarities with painting *en plein air*. In both, the painting must be completed in a limited time. There is only so long that a person can hold a pose; and when painting outdoors, the light changes rapidly: you could soon be painting a scene very different to the one you started. Also, making as few adjustments as possible after the sitting is the intention in both. The demands of this sharpen your senses and involve your whole being. A disciplined approach is therefore essential: not only to your painting, but also to your materials – this is not the time to be searching for your favourite brush or discovering that you have run out of an important colour.

For the direct approach explained within these pages, the desired outcome is a fresh, lively portrait that captures not only the likeness but the moment. It is an all-consuming, exciting experience that requires your full attention – and it will be both challenging and enjoyable.

I prefer to work from life. As a result, most of the demonstrations and portraits in this book are painted directly from the sitter. The passionate energy that comes with working from life is often underestimated; I am certain that artists who work in this way produce a lot more work than those that don't. It is a passion that has become evident to me from the many life drawing workshops I have held, from academies worldwide, and from the plein-air painters who can be seen capturing the moment in temperatures below freezing or in bustling streets.

Of course, working from life is not always possible, particularly if you are working to commission. Photography might be the only way to achieve a mutually satisfactory result. How and when to use photography and how to interpret and understand the limitations of photographs are explained later in this book.

The most important ingredient for any artist is passion, together with the desire to continually improve. This is a guaranteed recipe for growth. I hope you will find inspiration for both within the pages of this book.

alla prima / ˈɑːlə ˈpriːmə /
Literally 'at first try', painting alla prima means that the portrait is completed in a single session.

en plein air / ɒn ˈpliːn eə /
Painting outdoors in natural light; as opposed to in the studio.

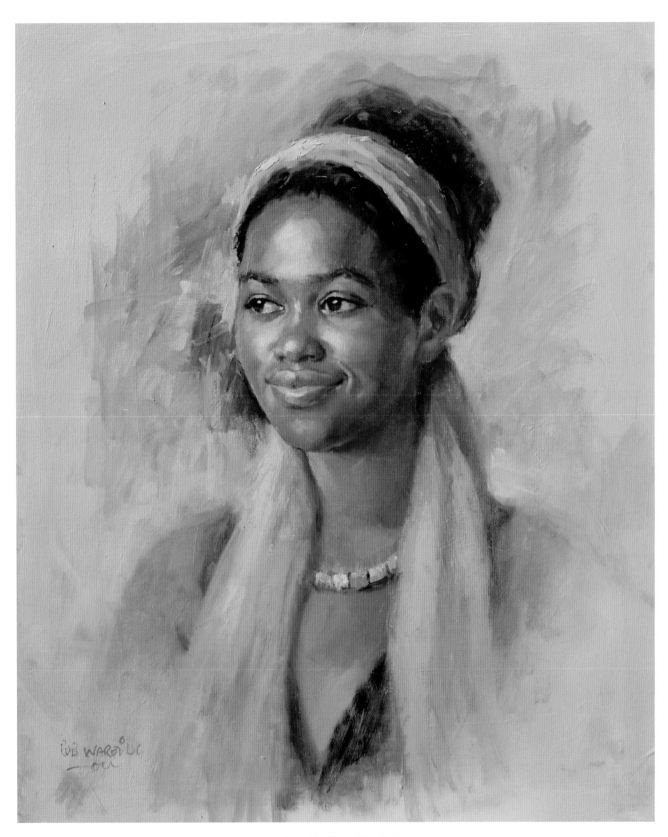

Lindo 51 x 61cm (20 x 24in)

Working
from life

What makes a portrait?

Painting directly from life, with the intention of completing the portrait in a single sitting, is a challenging and completely different experience from any other way of producing a painting. Indeed, it is so different that to compare it to working from a photograph or drawing is impossible.

The key to this approach being successful is intense observation: there is a great deal going on. You are looking intently at a three-dimensional human being that, no matter how still they sit to hold a pose, will naturally blink and breathe and make a hundred other tiny movements; as will you. The slightest shift by you gives another angle to the head. During a break, they laugh and talk, giving you more insight into their individuality. Quite apart from this, you will have your own emotional response to your subject to deal with. All this might sound terribly daunting, but believe me, these points are positives.

This part of the book explores some important underlying principles of my approach to portraiture; and the particular advantages of working from life.

SUBJECTIVE AND OBJECTIVE VISION

Some years ago, I was painting single-sitting portraits in a gallery during a holiday season. My appointment book was full. The thing that fascinated me during that intense time was that those subjects who appeared to be impossible – like the child who spent more time off the chair than on it – sometimes gave me my most successful portraits. After much thought and analysis, my conclusion was that it is the subtle balance between our subjective and objective vision at play. (I am not, however, recommending that you encourage your sitters to fidget!)

What I mean by this is that all we need is a glance for our brains to retain an image of someone – or any other object or scene, for that matter. This subjective image is a personal interpretation, which might alter slightly as we interact with the person and become more aware of certain character traits, but it remains an overall 'edited' image.

When we draw or paint, however, we break things down into coherent, logical shapes which are understandable and explainable in more objective terms. When we have a client who sits dead still, or when working from a photograph, we can become so objective that we totally lose the essence of the subject that our subjective vision provides. When this objective vision is removed – as with the moving child – all we are left with is our basic understanding of our subject and our instincts. It is the subtle balance between this objective and subjective vision that is needed to produce a good portrait.

THE FRAGILE THINGS WE CAPTURE WHEN WORKING FROM LIFE

A few years ago, a client for whom I had done a number of commissions contacted me to tell me that her husband had passed away and to request a few paintings for her. The first was a portrait of him in his dress suit from a photograph, while the other two were copies of a portrait I had painted of him from life. Working from somebody else's photographs is something I normally refuse to do, but in this exceptional case I accepted the commission.

The portrait from the photograph was relatively easy to do, as the references were very good. The copies of my painting from life were an eye-opener to me. I thought it would be easy – I had, after all, painted the original in approximately two hours. After a week of starting again a number of times, I managed two acceptable copies that still were not as lively as the original. I mention this to emphasize that the reactionary marks and split-second decisions we make when someone is in front of us are so fragile that recapturing a moment is almost impossible.

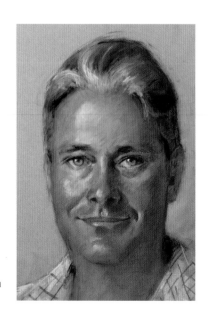

Ralph 46 x 56cm (18 x 22in)
This was the original pastel, made many years earlier, when my work was a lot tighter. I found it a lot harder to copy than I had anticipated.

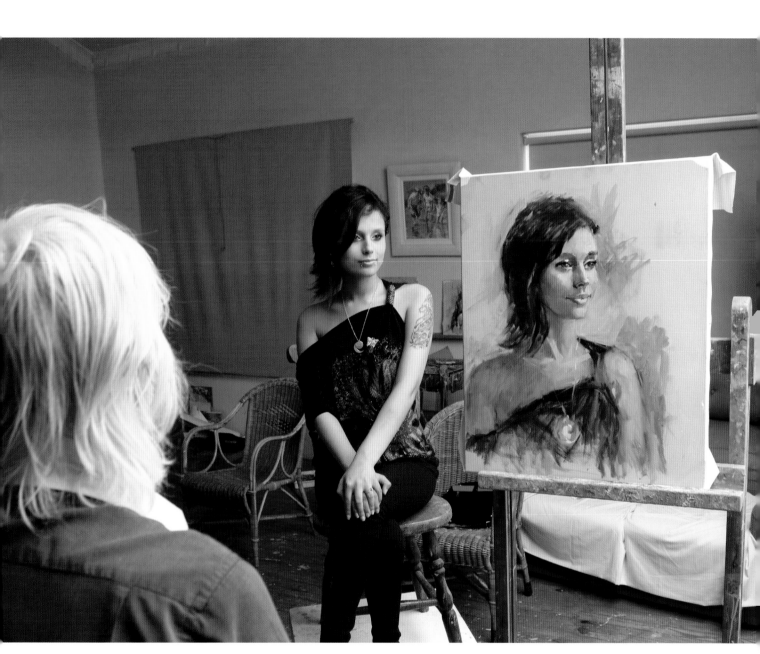

A typical example of working from life, where one
is reacting to the thousands of small movements
in the model.

THE BALANCE BETWEEN CHAOS AND ORDER

To paint a portrait in a single session from life, both a disciplined approach and a basic understanding of the proportions of the head are essential. Without these, you could spend the limited time you have trying to bring order to chaos. You also want to avoid being too rigid, as this will inhibit you from making meaningful changes and stop the creative flow. You will at best end up with a coloured drawing, and will more likely run out of time.

What we want is to work confidently, the painting to move forward and to remain able to respond instinctively to changes in our sitter at any time; knowing that we can correct and change bothersome areas when they occur. This confident approach can be seen in the paintings of many great painters like John Singer Sargent (1856–1925), Anders Zorn (1860–1920) and Nicolai Fechin (1881–1956). Fechin in particular was a master of bringing order to chaos, starting with an instinctive abstract and ending up with soul-filled portraits that one never tires of looking at.

The balance between our logical and our instinctive, intuitive sides is found when our understanding and practical skills reach a level where they become second nature. An analogy would be driving a car: with experience, the acts of changing gears, accelerating or braking become almost instinctual, allowing us to focus on the path we are travelling, negotiating traffic and potential dangers.

In all alla prima painting, there is a time limit to consider. Even with breaks, three hours is the most you can expect anyone to sit in a session, and an hour-and-a-half to two hours is more likely. Having realistic expectations of what can be achieved in that time is therefore essential. This does not mean that larger paintings cannot be worked in this way, or have to be finished in three hours. In these situations the artist is likely to finish the head in the first session, leaving other areas to tackle in subsequent sessions. The result is thus painted wet-into-wet over a few sessions. It is also not against the law to make subtle changes afterwards, so long as the fresh, painterly qualities of this technique are retained.

My own approach to this task has evolved over a number of years of finding ways to cope with the inevitable problems that occur. Some could so easily have been resolved before they happened; and I hope that sharing my solutions with you will help you to avoid the pitfalls that lead to chaos.

BASIC COMPOSITION

There are a few important considerations to resolve before you start painting:

Lighting A harsh, dramatic light in a darkened room might add strength and character to an elderly man by casting hard shadows and emphasizing weathered skin, but is certainly not suited for a typical portrait of a woman or child – here a softer, gentler lighting that softens the features is more in keeping with the subject.

Angle of the head The angle you choose to paint your sitter can greatly enhance the character and likeness of your subject and what you want to convey. For example, if you want to suggest the sitter is a strong athletic type, emphasizing characteristics like a striking nose and jawline in a three-quarter or profile pose will go a long way to conveying how you see your subject, because it will highlight the lines and angles. Equally, similar facial characteristics might be better conveyed in a full-faced pose if you want to suggest a gentle disposition, because it will soften the impact of these features.

Placement Although the design and placement of a head on a canvas is a lot simpler than when painting the whole figure, or painting more than one person, it is still an extremely important part of the painting. A lot of artists leave extra canvas when stretching their canvases. This allows them to move the canvas a little to the left or right or up and down later on. Realising how important this is – and how poor placement can totally ruin a good painting – some artists even frame their canvas before starting to ensure an aesthetically pleasing result. Generally speaking, the goal is to get the placement of the head on the canvas correct, the image sitting comfortably on its own, with no irritations.

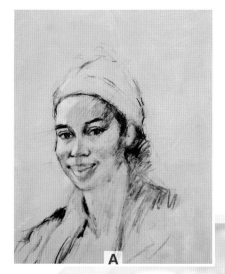

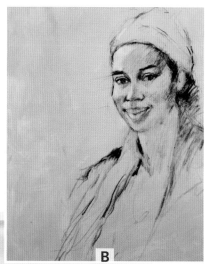

A

B

The importance of placement in composition

In composition A, above, I have exaggerated a common fault of placing the head too low and too far to the left, creating far too much negative space behind and above the head.

Composition B Is a little better but still has far too much space in front of the subject – it is almost crying out for a second person in front.

In the final composition (C), the head sits comfortably on its own within the boundaries of the canvas. A rule of thumb is to allow a little more space in front of the subject. This is especially useful in profile and three-quarter poses. See *Thulisile*, on page 101, to see how this composition was developed into a finished portrait.

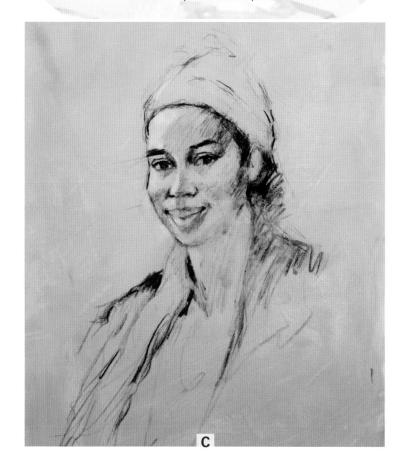

C

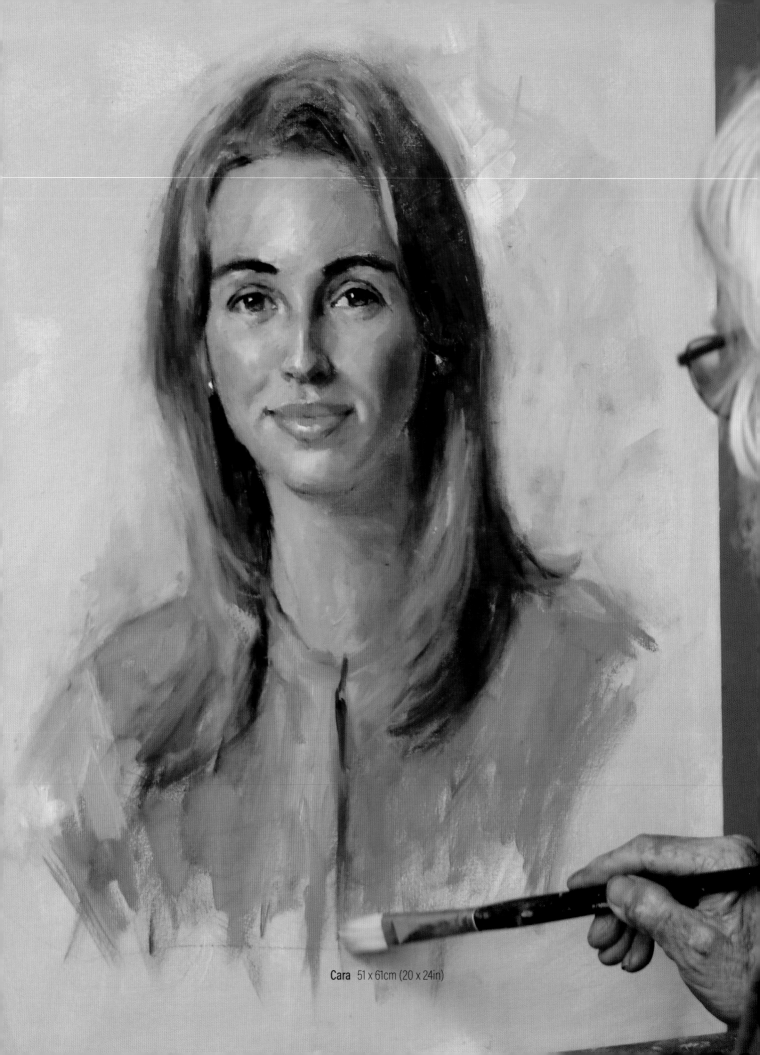

Cara 51 x 61cm (20 x 24in)

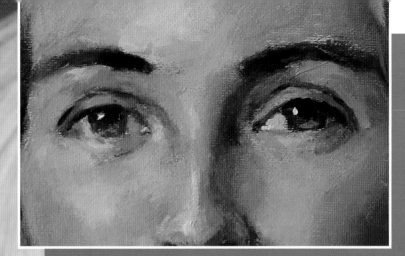

After a tonal underpainting, I normally begin the finishing by particularizing the eyes. This gives me a clear guide to the finish and positioning of the other features.

PAINTING *CARA*

Before starting the portrait of Cara, I had had the opportunity to meet and observe her in a relaxed social setting. This is not always possible but I do recommend some relaxed time with your subject before they pose for you – even ten minutes over a cup of coffee is enough. This time can give you some valuable insights which will certainly help you during the sitting.

My first observation was her dark hazel eyes and red hair – a very unusual combination. The second was a warm engaging personality but with a slight downturn to the mouth - this was going to be the area where most problems could occur. I am certain that anyone who paints portraits will agree that the mouth is by a long way the most difficult feature to paint. Even John Singer Sargent described portraits as 'a picture in which there is just a tiny little something not quite right about the

mouth'. This delicate feature communicates so much and has so many different positions that capturing it exactly, where it communicates the emotion that you want, can be elusive.

A problem we have to cope with as artists is that we live in an age where we seem to have bypassed all other human expressions in favour of the happy grin. If you do demonstrations, or have worked with others watching you, you will be surprised how many people watching feel the need to cheer your model up. Even my three-year-old grandson says, 'Say cheese!' and flashes a toothy grin when he sees a camera.

My advice when tackling the mouth is to remember that we see expressions and emotions in our peripheral vision; hence this feature must be painted softly. It is definitely an area where less is more.

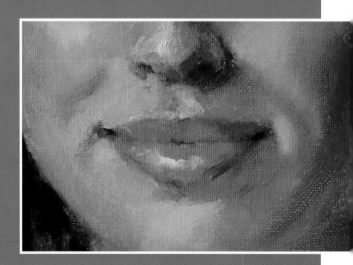

The mouth is painted softly. I am always aware of it becoming too isolated from the rest of the head. Less is more.

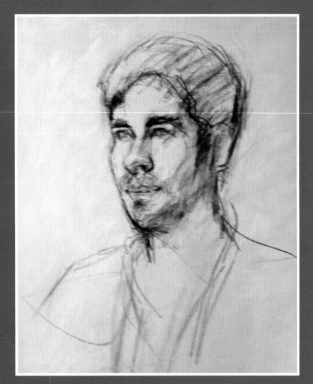

Initial sketch
A rapid charcoal sketch was the starting point; the focus here is on design and size.

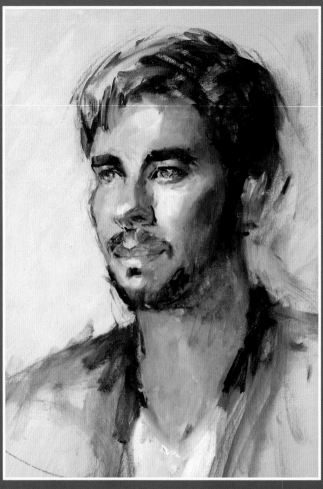

Stage 2
Full colour block-in, where the focus is on values and colour temperature.

PAINTING *WREN*

I had the advantage of having known Wren for most of his life, so my mental image of him was clear. I tried different positions and lighting, deciding that, for him, looking out of my studio window gave the best patterns of halftone lights and shadows to his head.

I started the portrait by rapidly stating the basic proportions and placement of the head using charcoal. With this stage complete, I critically evaluated my design, looking in particular at placement and size. Likeness and details are not a consideration at this stage, although certain particulars like the strong eyebrows and shape of the nose were becoming obvious focal points. Next, I brushed in the tonal values with a large brush

(filbert size 10) trying to match the tones and colours as closely as possible. I feel that this broad approach at the outset is important. If your initial drawing is too resolved, the temptation to simply 'colour in' the drawing can be great. Somewhere during the painting you will need to deconstruct the drawing to avoid ending up with a flat result.

After this second stage I could see where I was going with the painting, and I began to develop the finish. I started with the eyes, refining them until I was satisfied. With these key features in place, I could work out the exact positioning of the other features and take the painting to a conclusion. I decided to keep the clothing sketchy and the painting to be a vignette.

Filbert / ˈfɪlbərt /
This type of brush has bristles arranged into an oval, hazelnut-shaped tip.

Vignette /vɪˈnjɛt/
A portrait with no background or with such a subdued background that the head totally dominates.

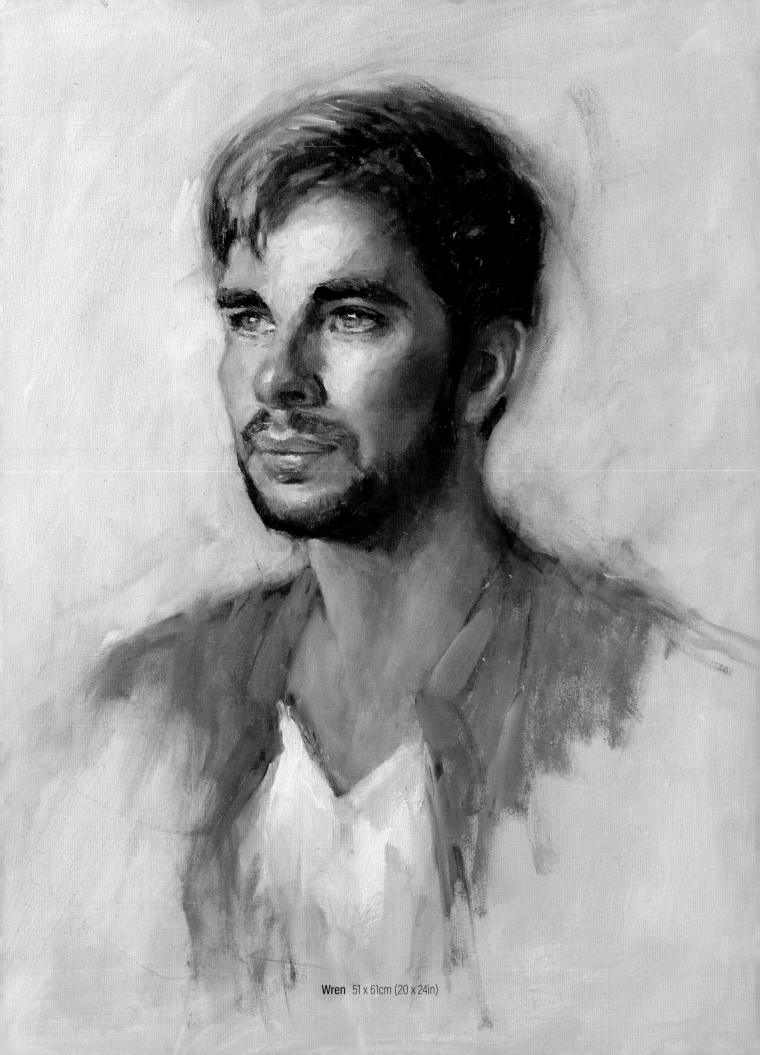

Wren 51 x 61cm (20 x 24in)

Materials

The tools and materials I use are listed over the following pages. My choices and preferences have evolved over many years of experimenting and with the help of the recommendations from many artists whose work I admire.

BRUSHES

I cannot stress enough how important it is to work with good quality brushes. They are an essential part of producing a painting. Good brushes not only make the process easier, but they also last and keep their shape for a long time.

I use brushes from Rosemary & Co (their Classic and Masters Choice ranges). I prefer filbert brushes to flats or rounds, as their flattened but rounded shapes allow a huge variety of marks to be made without changing brushes. The sizes I use are numbers 2, 4, 6, 8 and 10 in the Classic range; and 1, 2, 3 and 4 in the Masters Choice range, which are softer. I also have a 50mm (2in) brush in the Classic range, and a small size 2 watercolour brush which I use for drawing.

I find these brushes suit my way of working and, with care, last an incredibly long time. I actually keep two or three of each size and type of brush so that I am always working with a clean brush during the sitting. This is essential in order to keep the painting looking fresh – working with dirty brushes is a guarantee to producing muddy colours. The portrait artist Philip de László (1869–1937) was noted for having a large number of clean brushes at his side when painting, believing that they contributed to producing fresh clean colours on his canvas. This is evident when viewing his work.

PALETTE

I use a traditional large kidney-shaped wooden palette, on which I lay out my colours; always in the same way: from light to dark and warm to cool. The surface is French polished, which prevents the wood from absorbing the oil from the paints. This helps to make cleaning up straightforward, so although it is more difficult to clean than a glass palette, it has a number of advantages which suit my way of working.

Firstly, it measures 59 x 37cm (23¼ x 14½in), giving me a comfortablly large area on which to lay out and mix the colours. This allows me to work for a reasonable amount of time without having to clean up. It is also very light in weight, so despite its large size I am able to effortlessly hold it at a distance from my canvas and model. This allows me to stand back and observe subject and canvas together. From a distance, I can then mix the appropriate colours comfortably, with palette in hand. When working closer to the canvas I can put it on a table or on the drawer of my French box easel.

The palette itself is also a middle tone. Since most of my work is done on a mid-toned canvas, I can be confident that the colour I mix on the palette will appear the same on the canvas.

OIL PAINTS

Oil paints are pigments in an oil (usually linseed) base. They are ideal for painting portraits, owing to the ease with which changes can be made: you can simply scrape down offending areas using a palette knife, then repaint until you are satisfied. As they are slow-drying, such changes and corrections can be made almost indefinitely, which is not the case with most other painting media. Pastels and watercolours, for example, only allow for minimal change.

Softening and sharpening edges is easily achieved with oils, and a vast range of techniques are available to you. Oils are also a medium where transparent areas and thickly-painted opaque areas harmonize comfortably within the same painting.

Oils are available in high-quality Artists' paints and cheaper Students' ranges. Students' ranges use far less pure pigment than professional quality Artists' ranges, and as a result are less vibrant. The manufacturers I favour are Rembrandt, Winsor & Newton and Michael Harding oil paints, as their Artists' ranges are all high-quality, rich and vibrant.

My colours are titanium white, cadmium yellow pale, cadmium yellow deep, cadmium orange, cadmium red light, cadmium red, yellow ochre, raw sienna, burnt sienna, alizarin crimson and ultramarine blue. Two colours which I use occasionally are viridian green and ultramarine violet. We look at the reasons for this selection later in the book, on pages 90–97.

My palette and a selection of oil paint tubes.

SOLVENTS AND MEDIUMS

Genuine oils cannot be mixed or thinned using water; instead you use a solvent such as turpentine or white spirit. At the early stages of a painting, I thin the paint quite considerably with genuine turpentine. As the painting progresses, I tend to gradually use less solvent, until I am using the paint straight from the tube. I use mineral turpentine for cleaning my brushes at the end of a painting session.

In the dark areas, such as black hair or a black dress, I will use a medium which I mix myself (see page 93 for more information). The mixture is one part dammar varnish, one part stand oil and five parts genuine turpentine oil, prepared in a glass jar. This mixture keeps the area lively during the painting process. Without the medium these areas, which have no or very little white paint in them, become flat-looking when they dry. There is then a tendency to feel the need to repaint these areas and, if you do so, these areas will lose their transparency. Using the medium will help to prevent this from happening.

There is only one other time that I will use a medium, and that is when I go back to a painting after a day or two to either improve or correct an area. You can read more on making adjustments on page 68.

CANVAS

My preferred surface to work on is Claessens acrylic-primed fine linen canvas which I buy by the running metre (yard), then stretch and prepare myself. Occasionally I will work on cheaper cotton duck canvases for smaller experimental oil sketches.

When you buy and use canvas from the roll, there are always off-cuts. I use these by gluing them to pre-cut MDF (masonite) boards normally 20 x 25.5cm (8 x 10in) or 30.5 x 35.5cm (12 x 14in). These are great for doing tonal studies and gestural compositions.

Canvas must be primed before you begin painting, to avoid the oil soaking into the surface. Canvas can be bought ready-primed, or you can prime it yourself. Some primers can be problematic but I find Michael Harding's non-absorbent primer gives me the surface I like working on.

I very seldom work on a pure white canvas. I like to tone my canvas a light mid-tone, as shown opposite. Being plastic-based, acrylic paint dries waterproof and provides an extra coat of primer on the canvas. I find this helpful, as a lot of the off-the-shelf primed canvases still absorb some of the oil, making the surface difficult to work upon.

TONING THE CANVAS

This technique gives me the surface I prefer to work on. Using orange and blue acrylic paints with either white acrylic or non-absorbent primer, I mix the desired tone. I normally prepare these grounds well in advance so that the canvas has completely dried.

1 Lay out small pools of ultramarine blue, cadmium orange and a larger pool of titanium white acrylic paints on your palette.

2 Use a palette knife to mix and combine them into a neutral grey.

3 Apply it to the canvas quite thickly using a household sponge, then spread it out to cover the whole surface.

4 Leave it to dry and it will be ready for use in an hour or so.

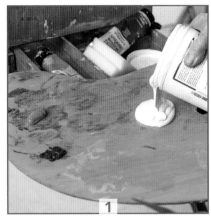
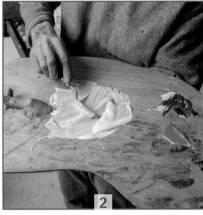
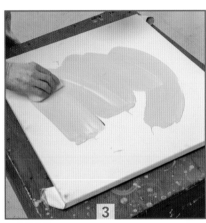

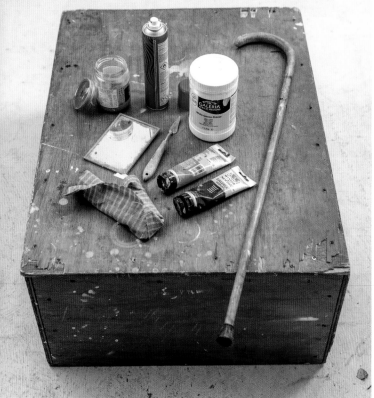

SUPPORTING MATERIALS

French box easel I find this easel ideal. It is sturdy, portable and can comfortably take canvases up to 76cm (30in) in height – I have even used it for larger sizes. It is indispensable when working on location.

Box I like working standing up so that I can see both my model and the painting from a distance. If the model is seated, I therefore need a model stand to raise the level of the sitter to the required height – approximately eye-level if painting an adult, or slightly lower if painting a child. My model stand is a sturdy well-made wooden box of sufficient size to accommodate a chair, but it is portable enough for me to take with me when painting on location.

Glass jars A selection of these are handy for carrying solvents and mediums safely.

Palette knife Although I use it sparingly, I find this an indispensable tool. You can use the flat edge to cleanly scrape away paint from the surface, allowing you to make corrections. A medium-sized palette knife can be used for mixing paint on the palette, blending on the surface, creating sharp edges and occasionally for touching in final highlights.

Rags and paper towels Unglamorous perhaps, but rags or paper towels are nevertheless essential equipment while painting, especially for cleaning your brushes.

Hand mirror I find the mirror a valuable aid for assessing drawing and tonal errors in your painting. Stand with your back to the painting, hold up the mirror and angle it so you can see the painting in it. Seeing everything in reverse seems to exaggerate the faults.

Walking stick Hung over the top of the canvas by the hook, leaning on the stick allows me to work on a wet painting without my hand smudging completed parts. Some artists use a mahl stick – a stick with a soft pad – for this purpose.

Hairspray As I like to begin my portraits with charcoal, I sometimes give the drawing a spray with hairspray to prevent it from muddying the colours when I start applying paint to canvas. This depends on how dense the charcoal drawing is – a light sketch may not need it.

Acrylic paint As described on page 27, I use acrylic paints to tone the canvas, giving me the surface I like to work on best. I prepare the canvases well in advance so they can thoroughly cure.

After sharpening a stick of charcoal with a blade, you can create almost needle-point sharpness with a fine-grained sandpaper. Of course these points don't last long, so I normally have a few sticks sharpened before starting.

SKETCHING MATERIALS

My favourite sketching tools are charcoal and pastels. Both of these media allow me to explore potential paintings in a tonal manner.

Charcoal and pencils I use Nitram Fine Art charcoal (B grade) in combination with Derwent charcoal pencils for gestural studies and preparatory sketches. I normally sharpen two or three sticks before a sitting.

Knife and sandpaper Both charcoal sticks and pencils can be sharpened with a utility knife, and you can create very fine points by honing them with fine grain sandpaper (see above).

Chamois leather and erasers Chamois leather and kneaded putty erasers are wonderful for pulling out light tones from your charcoal drawings.

Pastels I have worked with pastels for many years and apart from it being a wonderful medium on its own, as a sketching medium it has no equal. I can explore my subject in tone and colour, sorting out many pitfalls before beginning a painting. I will also occasionally use a white pastel to bring a few crisp highlights to a charcoal study, especially if done on a toned paper.

Planning
your paintings

Before anything else can be done, the fundamental questions 'what and who to paint?' must be answered. They are questions I am often asked, and for which there are a hundred answers. To lead you to being able to find your own inspiration, let me share a few ideas that have inspired me over the years and helped me find new approaches.

Firstly, do not underestimate the importance of a sketchbook. I have been scribbling in sketchbooks – indeed, on any loose pieces of paper I can find – for as long as I can remember. Most of the results are meaningless doodles, whilst others are either attempts to capture something or someone I have seen previously, or to try to accurately depict what I am looking at in that moment. This habit, I believe, has been the beginning of almost every painting I have done.

When finances allow, I hire a model for as long as possible. It always surprises me after a day or two working with a model how many paintings I am inspired to do. The benefits far outweigh the fees. If hiring a model is difficult for you as far as finance, space or other circumstances are concerned, my suggestion is to attend life drawing sessions and join art groups that meet regularly to draw and paint from life. Apart from the benefits of the sessions themselves, you will find the company of like-minded people stimulating.

I am always on the lookout for an interesting face to paint and will often ask a potential model to sit for me. Sometimes this can be awkward, so my wife or another third party does the asking. Once the subject and sittings have been arranged, it is time to get back to the sketchbook and make practical decisions on the design and lighting, having a clear visual idea of how you want to portray your subject.

These decisions begin the final stage of planning: composition. This is an extremely important part of creating a painting. No matter how powerful your idea or reference, it can be weakened or even totally ruined by poor composition. In simple terms, composition is the first thing we see when we look at a painting: the design, the contrasts, the colour. It is also the reason why people will walk past one painting and be attracted to another.

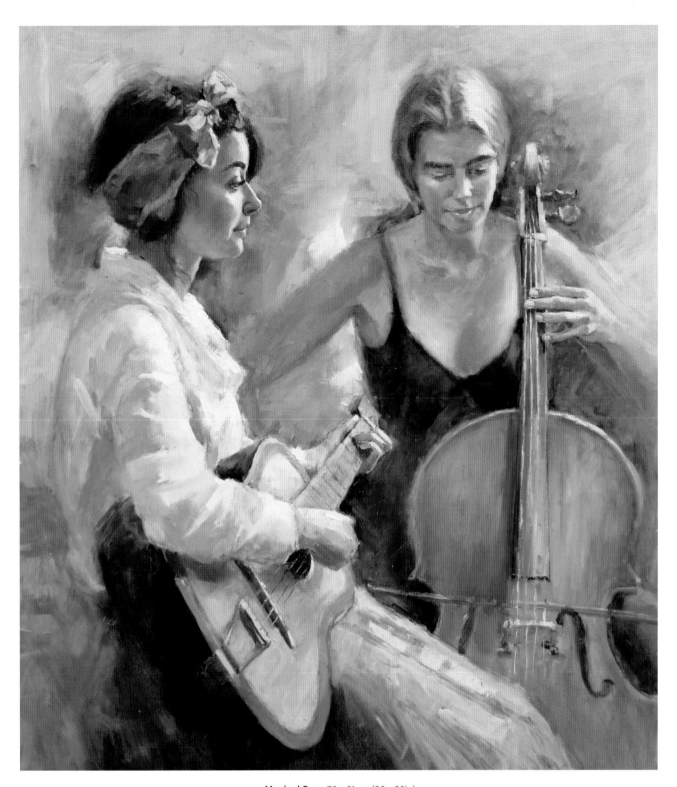

Musical Duo 76 x 91cm (30 x 36in)

My wife is a musician, so I have often been in situations which involve the things I love painting: portraits, figures and colourful characters. Having these two ladies in the studio at the same time was a rare event, so I made a number of quick twenty-minute pastels and a couple of small gestural oils to test different compositions before embarking on this final painting.

Preparation

Whether you are painting a commission or painting someone that you personally find interesting, a certain amount of preparation before you start will go a long way to producing a successful painting. Completing small gestures studies and experimenting with different angles and lighting situations will help you to establish a clear visual image of the intended painting. At the very least, this procedure will show you what not to paint.

CHOOSING A SUBJECT

This is a very important point for beginners and painters who would like to have a go at painting a portrait: some people are much easier to paint than others. If a student begins with an easier subject, the chances of the painting being a reasonable likeness are good, thereby encouraging the student and making them more likely to improve and grow as an artist.

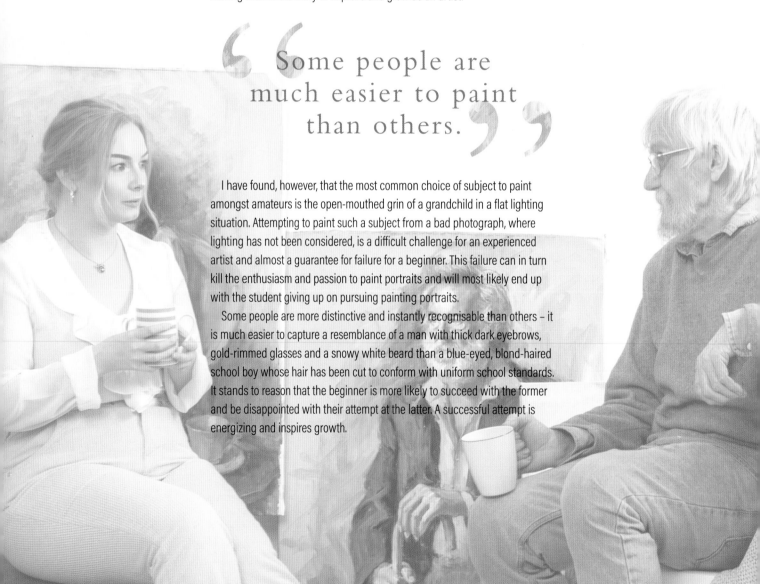

> **Some people are much easier to paint than others.**

I have found, however, that the most common choice of subject to paint amongst amateurs is the open-mouthed grin of a grandchild in a flat lighting situation. Attempting to paint such a subject from a bad photograph, where lighting has not been considered, is a difficult challenge for an experienced artist and almost a guarantee for failure for a beginner. This failure can in turn kill the enthusiasm and passion to paint portraits and will most likely end up with the student giving up on pursuing painting portraits.

Some people are more distinctive and instantly recognisable than others – it is much easier to capture a resemblance of a man with thick dark eyebrows, gold-rimmed glasses and a snowy white beard than a blue-eyed, blond-haired school boy whose hair has been cut to conform with uniform school standards. It stands to reason that the beginner is more likely to succeed with the former and be disappointed with their attempt at the latter. A successful attempt is energizing and inspires growth.

MEETING THE SITTER

Meeting the model or client before the sitting is advisable. This is not always possible with commissioned work. Fifteen minutes of casual conversation over a cup of coffee can give you valuable insight on how best to portray your subject.

Some people find sitting for a portrait extremely difficult, so having this time to create a comfortable relaxed working relationship can be very helpful. It is also a time when you can sort out practical issues such as clothing, jewellery and the size of the painting.

There are pros and cons when painting someone you know. The positive side is that you instantly know whether or not you are on the right track. The negative side is that you are less likely to see them objectively because your subjective vision of them will be deeply ingrained from thousands of different situations and moods you have seen them in.

HOW MANY SITTINGS?

The number of sittings you will need largely depends on the complexity and size of the painting. A simple head study might require only one sitting, while a more complex three-quarter length, life-size portrait with hands and detailed background could require five sittings. I find having some time with the subject before the sittings to be helpful in planning the scope of the portrait, and thus deciding how many sittings you will need.

My choices

There is a big difference when I choose the model to when one is chosen for me. My own choice has always been of people who stand out in a crowd, with a great deal of contrast – dark hair against pale skin, with a definite brow region, would be one example. Unique or unusual features, such as obvious dimples, is another. A third is appealing expressions: a serious, determined expression in a man with a strong bone structure. The list is endless. I avoid the ordinary and bland when painting for myself, but when accepting commissions you don't have those choices and they can be very challenging.

DECIDING ON A POSE

Portraits painted full-face are the most common choice of pose for historical portraiture. More adventurous poses and lighting arrangements, such as having the head turned and looking away in the three-quarter or profile position, are normally seen when the artist is painting a friend or a model of their liking. With no-one to please but themself, the artist is free to be more experimental and loose in their painting technique. The size of the painting will depend largely on where the painting will hang, and is usually determined by how much of the body you want to include, as most portraits are worked at close to life size.

My approach when posing a model is first to decide which side of the face will be predominantly in the light: people's faces are seldom symmetrical and can appear quite different when viewed from different sides. I then pose the body position – even in a head study, the body position can have a large effect on how the light falls on the neck. For example, a woman with an attractive long neck would look frumpish if posed head-on in a hunched position. In larger paintings, body position and hands are critical considerations.

The next observation I make is to notice whether there is a natural lean to one side. Some people find it very difficult to hold a straight pose. Their heads are comfortable at an angle, and not taking it into account can give you a lot of problems with your drawing – besides, you don't want to spend the entire sitting asking them to straighten their heads. Sorting out these things before painting can be very helpful. It is worth remembering that sitting for you is often a model's first experience of sitting for a portrait, so making them comfortable is essential. Blaming your model for you not taking a few basics into account is certainly not going to help. With that said, most people who have sat for me have sat remarkably well.

Pose and commission work

The main difference in painting someone for yourself and commissioned work is that with the former you choose the model, and you are free to paint your version of the model any way you like. In contrast, when accepting a commission a number of things have to be discussed with your client before starting. This includes size, medium and style. Most commissions come from people who have seen examples of your previous commissions or from recommendations; hence you should have a clear idea of what is expected before you start.

Having good communication with your client can go a long way to a commission being mutually successful. I have found over the years that women and children are much more comfortable keeping eye contact with me than men. This might be the opposite for female artists or it might just be a 'man thing'.

I will generally turn down a commission from someone else's photograph unless the image is particularly good and even then will ask the client to supply as many supporting photographs as possible to give me a general feeling of the subject. Requests for commissioned portraits from photographs are often of someone deceased so turning these down can, at times, be awkward.

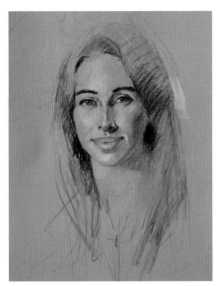

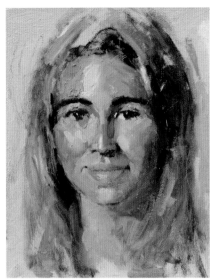

Far left: A quick pastel drawing, made in approximately twenty minutes.

Left: This gestural oil sketch of Cara, which also took approximately twenty minutes, measures 20 x 25.5cm (8 x 10in).

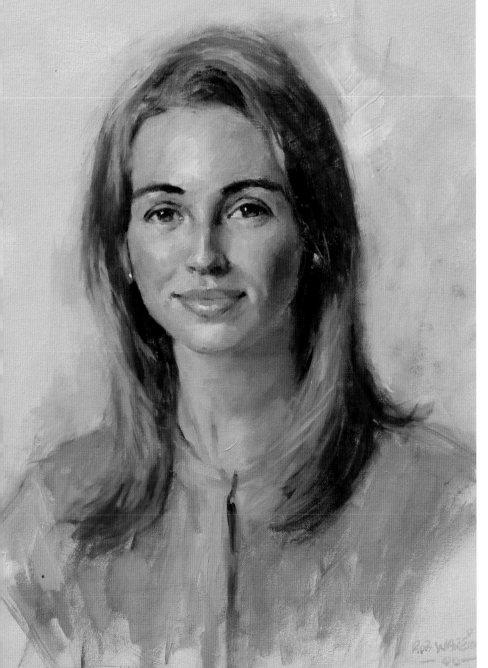

FULL FACE

Face-on, or slightly turned, with the subject having eye contact with the viewer, is the most typical pose for a traditional portrait. The biggest advantage of this pose is that the subjective likeness of the subject is more obvious – the individual's expression and characteristics are most evident in this pose. Painting a full-face pose will soften the lines of the head and face, which can make the sitter look less masculine – usually something of an advantage for female sitters, and to avoid in men. For the latter, a little turn of the head and stronger contrast between light and shade can put more emphasis on their masculinity while retaining a full-face pose.

Cara 51 x 61cm (20 x 24in)
This full-face portrait was painted alla prima in approximately two and a half hours.

THREE-QUARTER FACE

The head turned away in a three-quarter pose creates a more three-dimensional impression than a full-face pose. Rather than focussing on the face, three-quarter or profile poses (see opposite) give greater emphasis to the head as a whole. As a result, these poses tend to create more interesting patterns of light and shade than full-face, and better emphasize the character of the sitter.

The three-quarter face pose can also emphasize the bone structure and unique physical characteristics of your sitter more. Emily (below) is an attractive, athletic-looking woman whose strong, angular features I felt were more evident in a three-quarter pose.

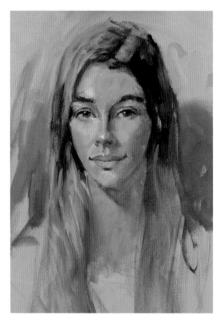

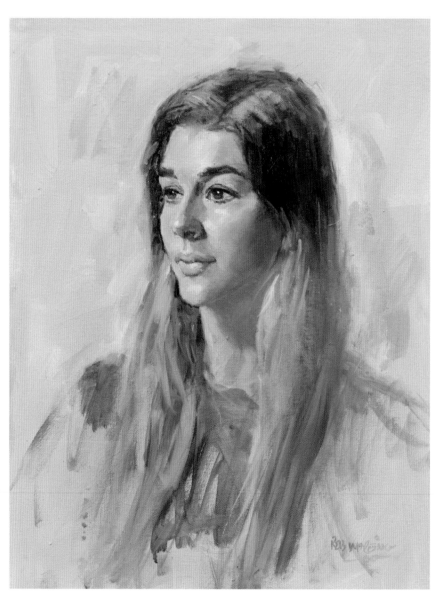

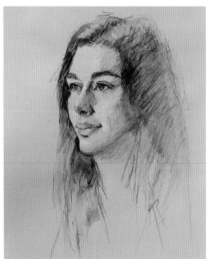

Top: After completing this full-face oil sketch of Emily, I decided a three-quarter pose would be more suited to her distinguished features.

Bottom: This charcoal sketch allowed me to assess the pose before starting the final painting.

Emily 51 x 61cm (20 x 24in)
The finished portrait was painted alla prima in three hours.

PROFILE

In some cases a side-on, or profile, pose is the position that yields the strongest, most vibrant resemblance of the sitter. The shape of a nose or chin will be more evident in profile, and this pose can give valuable insight into the person's unique appearance.

Despite these advantages, a profile is seldom the pose of choice when painting commissions, which is unfortunate. Even if the final pose is to be different, quick gesture sketches (see page 44) of a model's profile are very useful.

In the portrait below, the strong bone structure of the cheek and the indentation below it create a permanent dimple that is more evident in profile. The shape of the head and whiteness of the beard also contribute to leaving us no doubt who it is. Some of these qualities would have been lost in a full-face pose.

This of course does not apply to everyone, but when painting someone of my choice I certainly consider painting a profile as one of my options. My preference when painting a profile is to pose the subject so a little of the more distant eye can be seen.

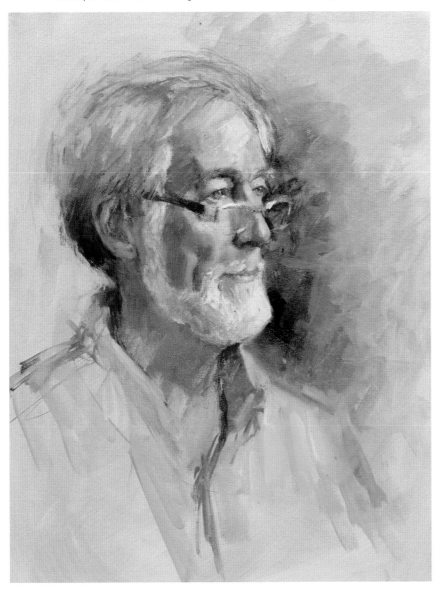

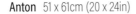

Anton 51 x 61cm (20 x 24in)
I had previously painted Anton's profile facing to the left in pastel. I decided on this occasion to paint his other profile (facing to the right) in oils.

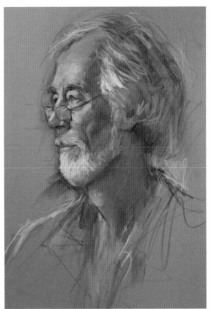

Top: A pastel portrait, made on a previous occasion.

Bottom: Charcoal drawing, made as a preparation for the oil portrait.

Composition

Once you have a basic idea in mind, you can begin more formal planning. Composition – the placement of the figure in the space, how the sitter is posed and lit, and the manner in which they are painted – will affect the mood of the resulting portrait, and allow the artist to make a particular statement about the sitter's character.

COMPOSITIONAL BASICS

With a portrait head-and-shoulder study, the composition is relatively simple: the head sitting comfortably around the centre of the canvas with a little more space in front of the head than behind (this applies mainly to three-quarter and profile poses). For full-face poses, the centre of the canvas is fine. You can see examples of both below.

One still has to consider contrasts, however. A striking blonde or elderly white-haired character will have more impact on a darker background than on a white canvas. How dark you paint the background also depends on the mood you want to capture. For instance a blonde seven-year-old girl on a black background will certainly not convey a feeling of youth and innocence. In this instance, a light halftone with a tint of blue would be enough to show her hair and be more in keeping with the subject.

MORE COMPLEX COMPOSITIONS

When one is painting larger paintings, such as those with more than one person on the canvas or a three-quarter length figure, the design becomes more critical. The example opposite, *Portrait of Charlotte*, looks at this. With her arm relaxed over the arm of the chair and the cast shadow against the wall in the background, I felt there was enough interest on the right-hand side. To provide visual balance, there needed to be some definite interest on the left-hand side. I therefore included a vase of flowers and suggested a painting behind Charlotte. This balanced the background and created the illusion of space around the model.

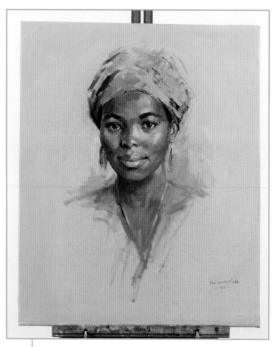

The mouth of this full-face portrait is roughly in the centre of the canvas, with plenty of space around the whole head.

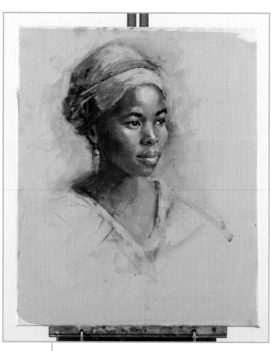

Here, there is is more space in front of the sitter than behind – this leaves some space for the subject to look into.

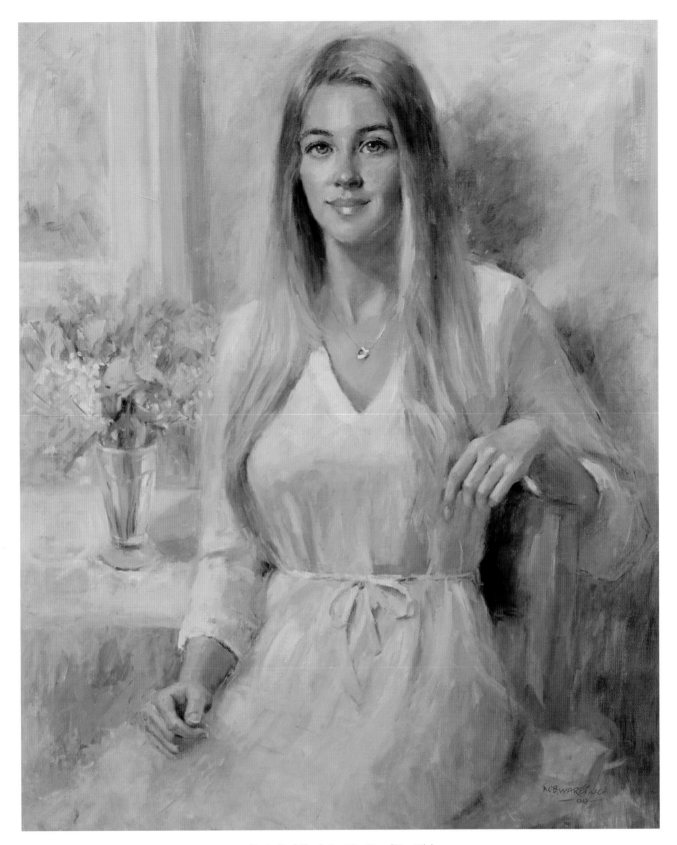

Portrait of Charlotte 76 x 91cm (30 x 36in)
The size of the canvas and the pose demanded
particular consideration of the shapes and colours used
in the background. I was careful to avoid strong colours
and high-contrast items which would have clashed with
the soft colours in the portrait.

KEY, MOOD AND ATMOSPHERE

Creating the right mood for your subject is an important consideration before you begin. Deciding which tonal key would best suit the subject is my first consideration before starting. Most of my paintings are painted in a middle key, where the majority of values are in the middle on the value scale (see pages 80–89 for more on value). I push the values toward the high or low end according to the subject. For certain effects you might wish to experiment with high or low keys.

The paintings of the French Impressionists of the nineteenth century were normally high in key to enhance the feeling of sunlight. Strong changes in colour, rather than value, were used to separate light from shade. As a result, with very little difference in the values, they therefore look much more effective when viewed in colour: black and white photographs can make them appear flat.

A harsh light against a dark background can be successful in a portrait of an elderly character but will result in failure when painting a young woman or child – here, softer lighting and a gentler background would be more appropriate. Dramatic effects can be achieved by using two distinctly different lights – one warm and one cool – although one light source must be dominant for this to work. In these situations the darker shadows appear down the centre of the face.

Expression and perspective are also important. In a typical boardroom portrait, for example, positioning the subject above your eye level and giving them a confident expression will enhance the image of them being a successful business person or leader. Conversely, looking down on your subject and giving them a demure, shy expression would typically be more appropriate in a painting of a child or young teenager.

Mia 51 x 61cm (20 x 24in)

In this high-key portrait, most of the values are on the light side of the value scale with little difference in the values between light and shade. This soft lighting is well-suited to the sitter, softening the delicate features.

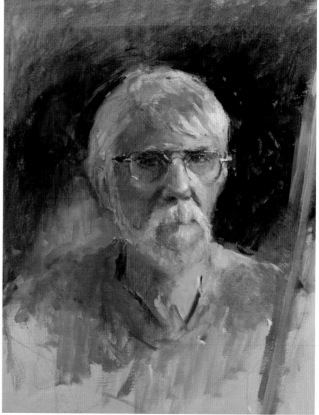

Self-portrait 51 x 61cm (20 x 24in)

In this portrait, most of the values are on the dark side of the value scale. With a dark background and most of the head in shadow, it is a low-key painting. Note, however, the inclusion of contrasting highlights to add drama.

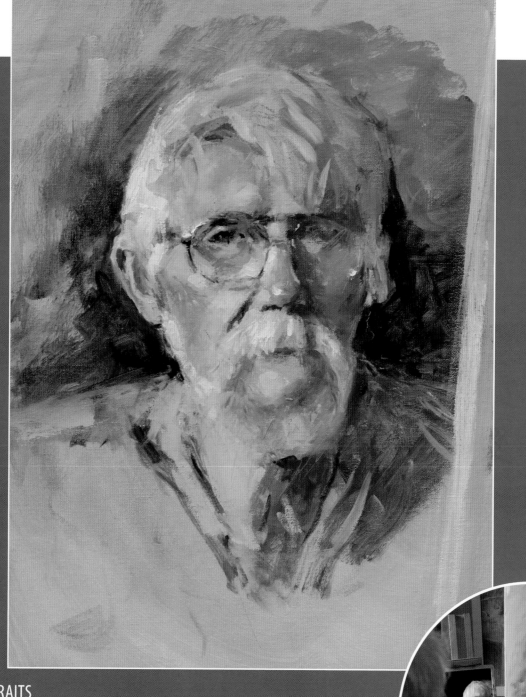

SELF-PORTRAITS

The most common response I get from students when suggesting that they work as much as possible from life is that they can never get anyone to sit for them. Well, all you need is a mirror positioned in front of you and your problem is solved. Self-portraits are an interesting exercise and great for improving your observational skills. They are easy to set up and the model is always available and free!

Many great artists have executed self-portraits. Rembrandt (1606–1669), for example, painted a large number of self-portraits, leaving us with a visual record of his likeness from youthful student to old age.

A self-portrait is a perfect, no-pressure chance to experiment with pose and composition, using the information on the previous pages.

The two self-portraits shown here, although similar in pose, are totally different in lighting. In the self-portrait above, the majority of the head is in the light, while in the other self-portrait on the facing page, the majority of the head is in shadow.

Changing the lighting, background and pose of your subjects gives you endless possibilities to try, and self-portraits are a perfect place to experiment.

LIGHTING THE MODEL

Lighting is one of the most important considerations you can make before beginning a painting. Spending time exploring different lighting arrangements is well worth the effort and can go a long way towards capturing the essence of your subject.

In the northern hemisphere, having a high, north-facing window in your studio will ensure no direct sunlight falls into the room, resulting in constant cool natural light on your model. In the southern hemisphere, you will need a south-facing window to achieve this. This type of studio has long been favoured by prominent artists, past and present, to ensure consistent natural diffused daylight with no direct sunlight coming into the room.

There are many situations where artists have to rely on artificial lights to create the desired lighting, particularly with commission work. As a lot of your work as a portrait painter is done on location and natural daylight can be totally inadequate during the winter months, having alternatives becomes essential.

FIRST LIGHT AND SECONDARY LIGHT

The traditional approach to lighting a portrait is to place a single light source above the head at a forty-five degree angle. I prefer to call this light source the 'first light', because there will always be a lot of secondary, ambient light around that dilutes the strength of the shadows. If the secondary light is too strong, you can use a folding screen with dark drapes to reduce it, which has the effect of strengthening the influence of the first light source on the model.

I find a softer, almost flat, lighting source ideal for typical portraits of women and children, because the resulting transition between light and dark is slight. The edges are thus softened, creating a traditional gentle appearance. This approach is very evident in the beautiful portraits of Lady Agnew by John Singer Sargent (1856–1925) and Lady Rockwell by Sir William Orpen (1878–1931).

More dramatic lighting, where the contrast in intensity between first and secondary light is great, will yield firmer edges. This type of lighting creates sharp contrast between light and shade, adding strength to areas like the cheekbone and jawline, lending itself more to painting traditional portraits of men.

ARRANGING THE LIGHT

The important thing is to arrange the lighting to complement the feeling you are aiming to achieve. The examples opposite show a few lighting situations I use when painting portraits:

Three-quarter lighting This form of lighting is the most common way of lighting the model. Depending on how you arrange the first light, you can alter how much of the face is in the light. This is an approach I use a lot when painting women and children as there is less shadow and, with most of the face is in the light, the result is softer. In the top-left example the light is left of centre, leaving a third of the face in shadow; while for the example on the top right I placed the first light right of centre, leaving a quarter of the face in shadow.

Two lights Using two lights can result in interesting lighting effects. It is important when using two lights that one is dominant and closer to the model. I use this arrangement mainly when playing with colour, using one warm and one cool light (see page 98 for more on colour and light). In the example opposite, the combination of lights helps to define the jawline in shadow.

Overhead lighting The light is positioned directly above the head resulting in the cast shadows falling directly below the nose and chin. This highlights the cheekbones, but can make the eye sockets look like holes. I use this lighting only on very rare occasions, for example to emphasize cheekbones in a character study.

cast shadow / kɑːst ˈʃædəʊ /
Shadows projected onto the object or nearby surfaces, caused by the object blocking the light.

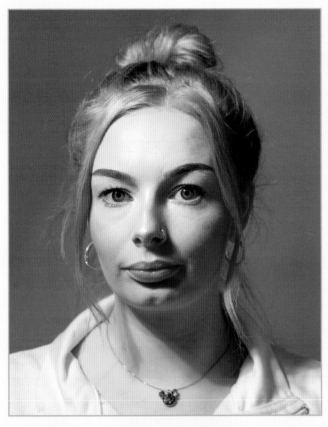

Three-quarter lighting

Third of face in shadow.

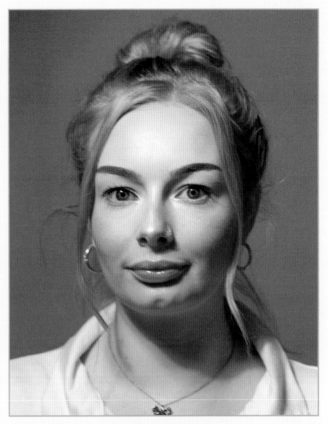

Three-quarter lighting

Quarter of face in shadow.

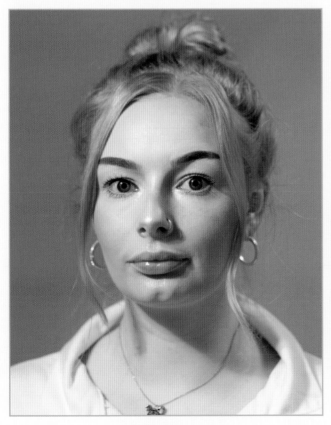

Two lights

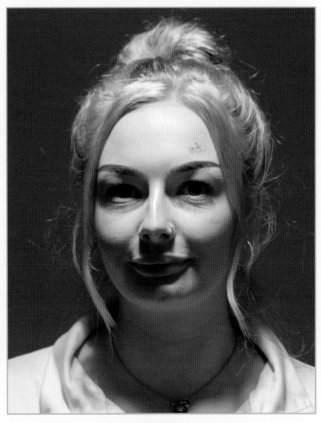

Overhead

MAKING STUDIES

Before starting a final painting I find doing some preliminary studies useful. They are done quickly and their only purpose is to explore alternatives and show me if I am on the right track. Accurate drawing is the least of my concerns in these studies and I focus only on tonal relationships and colour. Sometimes – although admittedly very rarely – they have something that the finished work does not.

I prefer pastel for these quick gestural studies as I am working with value and colour and can very quickly see the final picture in my mind's eye. However, I also make gesture studies in charcoal (see below) or oils. More examples of gesture studies in oils can be seen on the following pages.

gesture study / ˈdʒestʃə ˈstʌdi /
A study that aims to capture the form, pose and movement, in which speed is valued over precision.

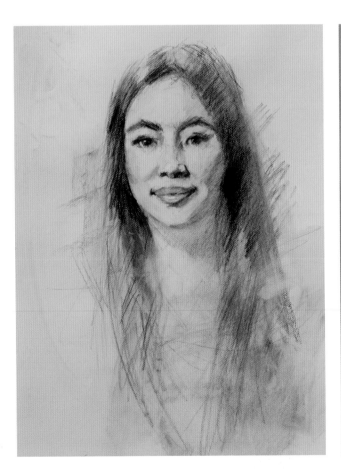

Example gesture study in charcoal.

Example gesture study in pastels.

PHOTOGRAPHY

Although this book focuses on the importance of working from life, it would be remiss of me not to mention how artists have used and still use photographs to complete their paintings. One thing is certain: if you accept commissions, you will definitely have to deal with the many situations and requests to work from photographs during your working life.

Using photography has always been a touchy subject amongst artists, inciting emotional responses that range from the extreme – the representational artist Pietro Annigoni (1910–1988) called the camera the 'murderer of dreams' – to the almost apologetic; many artists are reluctant to admit they use photographs to create their paintings, as though it were somehow shameful.

After four decades of painting professionally, during which I have also become familiar with the working methods of many other artists, I feel qualified to discuss the pros and cons of using photographs in painting portraits. During this time, I have been fortunate to have earned most of my living working from life and regard this as an essential part of my practice. With that said, there remain occasions when working with photographic references is the only way to complete a mutually satisfactory result. Apart from the commissions

which would be impossible for me to complete without photography, there are two situations where I find the camera useful: The first is when I am meeting a model, during the first sitting. With so many options that have to be decided before painting, a combination of photography and small gestural paintings is ideal to get on the right track. Alongside completing three or more gestural sketches, I take photographs from various angles and with different lighting, and also experiment with backgrounds and clothing. This process allows me to go into the second sitting confident that I am on the right track.

The second situation is during the second sitting, while I am painting. Taking a photograph of the painting you are working on, not the model, can reveal faults that you might not have noticed. I say not the model because I have found that photographs of the model at this time can be deceptive and throw you off track.

Photography has developed a lot during the time I have been a professional artist and working from tablets and smartphones seems to be common practice these days. There is no doubt that it can be helpful in certain situations, but it can never replace the way we see as individuals and there is no substitute for the information gained and the growth experienced from working from life.

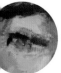

CASE HISTORY – PAINTING *STEWART*

CHOOSING THE MODEL

I have known Stewart for a number of years and have painted him several times. His strong, distinctive features mean he is always an interesting person to paint and, I thought, the ideal subject to show how I prepare for a sitting. I believe that beginners should always begin with an interesting character rather than attempting more challenging subjects.

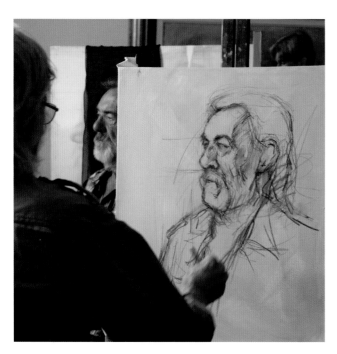

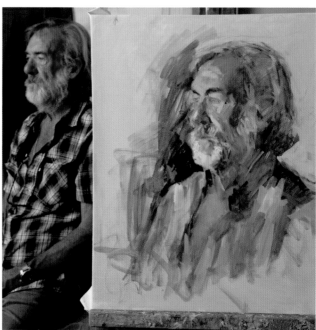

PLANNING AND COMPOSITION

In most situations I would usually explore various head positions, but before Stewart arrived I had already decided that I would like to paint his profile. After doing some quick oil gesture studies I decided on the mood, background and which profile to tackle.

The preliminary gesture studies I made before starting the final painting head off a lot of problems which I could have encountered, and helped to make the final portrait study of Stewart go smoothly.

FIRST SITTING

Having decided that I wanted to paint Stewart's profile, I had to resolve which profile to paint and how best to light him. I prepared three canvas boards, each 20 x 25.5cm (8 x 10in), and in the first sitting completed the oil gesture studies shown opposite. Each took approximately thirty minutes to complete and allowed me to try both sides of his head in different lighting.

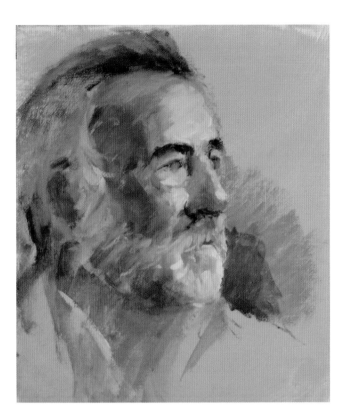

Gesture study 1

Cool natural daylight from the studio window was used for this study.

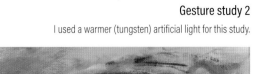

Gesture study 2

I used a warmer (tungsten) artificial light for this study.

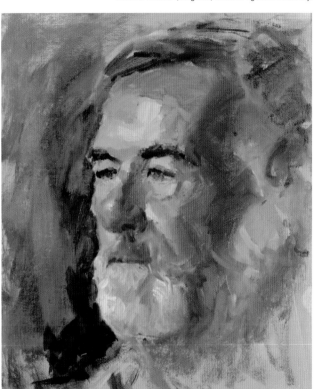

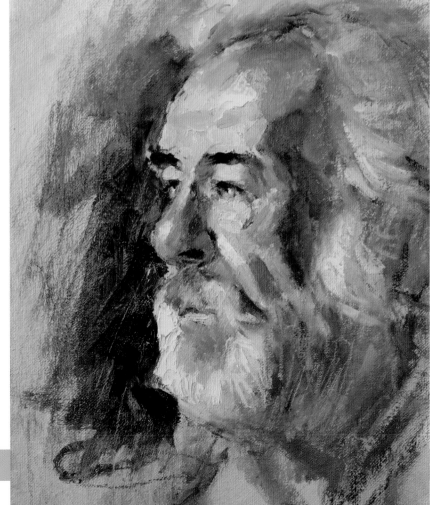

Gesture study 3

As with study 1, I used daylight for this study, but tried the model's other profile.

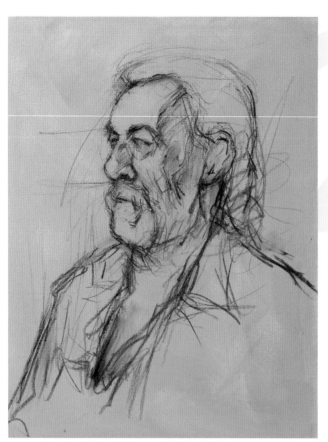

SECOND SITTING

Small gestural oil sketches, like those shown on the previous page, offer a quick way to experiment with different potential compositions. I felt that the third, painted in daylight and showing the left side of Stewart's face, gave me the most interesting and natural arrangement of light and shade. It was the obvious choice for the final painting. In preparation for the second sitting I stretched and toned the canvas a light, mid-tone, warm grey.

The final painting took approximately three hours to complete, and was worked in three distinctly different stages, detailed here.

Stage 1

With charcoal, I map out the proportions and placement of the head. This stage takes me approximately twenty minutes.

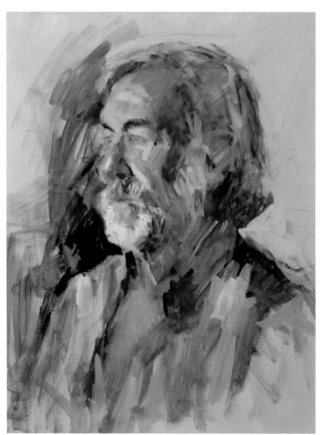

Stage 2

Before beginning this stage, I lightly spray fixative (or hairspray) onto the charcoal drawing to prevent it from mixing in with and muddying the paint. With a large brush, I block in the paint, creating a tonal range and in the process totally obliterating the original drawing.

Blocking in / ˈblɒkɪŋ ɪn /
The application of large simple shapes to establish the underlying forms and tonal range.

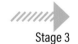

Stage 3

I now begin the process of modelling and finishing, keeping the painting moving forward as a total unit, avoiding getting bogged down on details which are just finishing touches to a completed work.

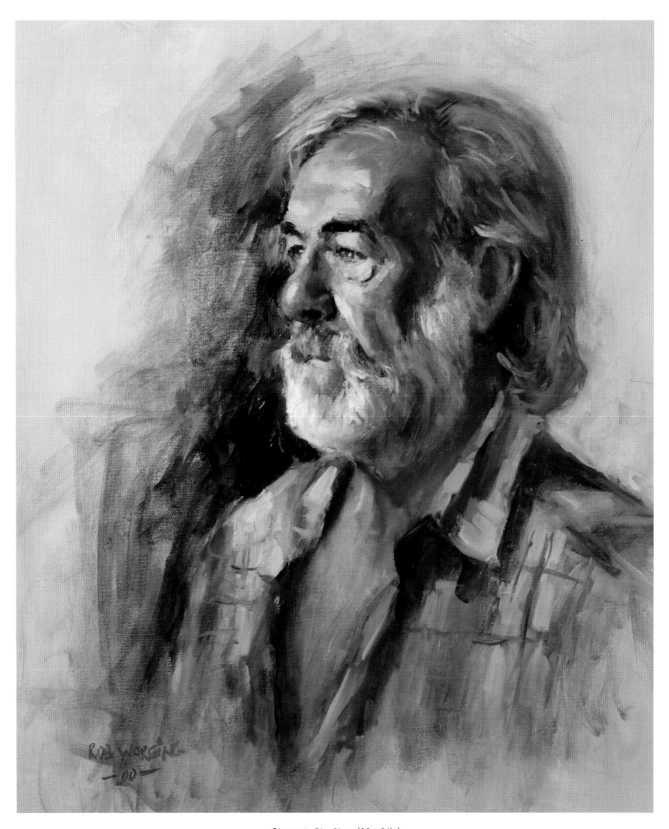

Stewart 51 x 61cm (20 x 24in)

CASE HISTORY – PAINTING *ROBYN*

CHOOSING THE MODEL

I was approached to do a portrait demonstration for a gallery's clients, with the gallery choosing Robyn as the model. Demonstrations are an intense event where one is expected to complete a finished likeness of the subject in an hour-and-a-half, answering questions as you work. Needless to say, such situations require your full concentration. There is a sense of theatre in these events, which usually brushes off on the model, who is an important part of the show. Robyn responded to the challenge perfectly and was a great model.

My first meeting with Robyn was thus not a relaxed one over a cup of coffee – but it still gave me valuable information for the final portrait. During the demonstration, I was struck by her dark eyes and eyebrows and I got know how her face moved with different expressions that occurred during the sitting. By the time the demonstration was over, we were relaxed in each other's company and I had a very clear idea of how I would paint her. After the demonstration, we arranged for sittings in my studio for a larger oil painting.

Early on, I experimented with light from directly above, but felt that felt it under-played her eyes and created too many harsh shadows.

FIRST SITTING

I began the first sitting in the studio experimenting with lighting (see above right). I then completed a pastel with the right-hand side of her face illuminated (sketch 1, below) and compared that with the pastel I had done previously for the gallery demonstration (sketch 2) where my light was positioned on the left. I decided that the light coming from the left in sketch 2 was more suitable.

During the breaks Robyn would sit effortlessly, her arm relaxed on the top of the chair, which led me into completing the small 25.5 x 35.5cm (10 x 14in) gestural study in oils. There was a lot I liked about the study, but the hands being directly under the head felt awkward. The angle of her head – slightly turned away and looking back – conveyed shyness, which was certainly not characteristic of her. All these factors led me to the final design opposite.

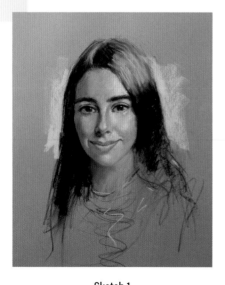

Sketch 1
Pastel study completed in the studio in the first sitting.

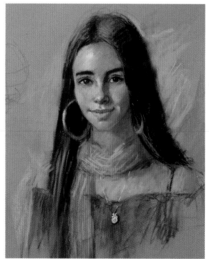

Sketch 2
Demonstration sketch completed for artists' gallery before the studio sittings.

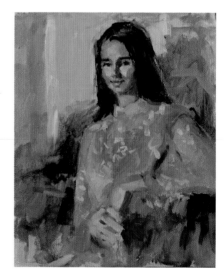

Gesture study

SECOND SITTING

With the final design now clear in my mind, I could begin. Placement in this painting was critical; the head and hands had to fit comfortably on the canvas. In the preparatory study below, the head was almost central. For the final piece, I refined things, positioning the head slightly off-centre towards the left-hand side of the canvas. This accommodated the positioning of the hands better, but did not create too much negative space behind the head on the right-hand side of the canvas.

The painting of the head progressed relatively smoothly, but the hands required a few attempts. The pink blouse with its delicate pattern was also a challenge. I tried to simplify and understate it so that it didn't detract from the face – in a portrait, the face will invariably be your focal point, so keeping other parts of the painting secondary is important. With the help of a few photographs, I was able to put a little more detail into the hands and blouse after the sitting, softening any edges which detracted.

negative space / ˈnɛɡətɪv speɪs/
The empty space between and around objects, as opposed to the positive shapes of the objects themselves.

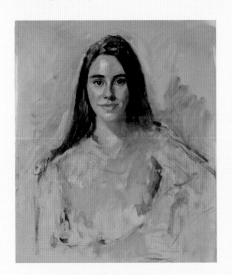

Preparatory study in oils
The final composition loosely painted in, with emphasis on placement.

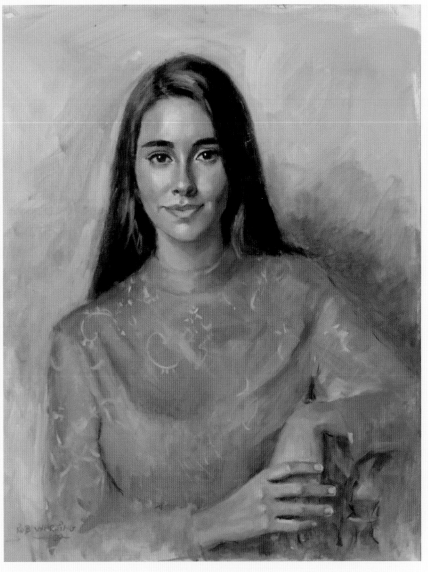

Robyn 61 x 76cm (24 x 30in)
I was pleased to have captured Robyn's direct, confident, good looks.

Achieving
a likeness

When painting portraits – or indeed anything else in a representational manner – drawing is critical. It is the area where things are most likely to go wrong. Whether you are using a sharpened pencil or working boldly with a large brush, it is still fundamentally drawing.

There is more to a successful portrait than accuracy of line, of course. The colours you use – and perhaps more importantly, the values – will also help the subject to be recognisable. More than that, you can use these qualities as part of a deliberate composition, in order to suggest a particular aspect of the character of your sitter.

Most artists like to do a suggested line drawing in charcoal or oils before beginning with bold brushwork; the drawing establishing the basic proportions and angles of the model. I believe this should be a quick suggestion, as an overly-refined and embellished initial drawing will encourage the artist to simply 'colour in' – the result usually being the stiff, hard-edged painting often seen in paintings done by beginners.

If you are scared of losing the lines of the initial drawing, you will be restricted by those same lines. The confident, competent artist does not separate the painting stage from the initial drawing, and is conscious of accurate placement even when painting large areas with a big brush. With this confident approach, the result will be a smooth, painterly and characterful portrait.

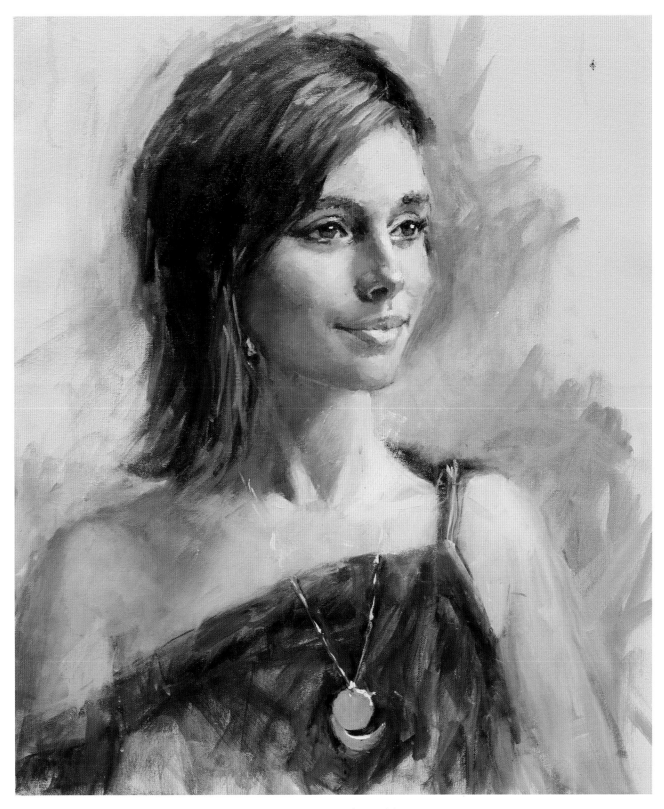

Raven 51 x 61cm (20 x 24in)

Drawing skills

Many years ago a tutor of mine said, 'I'll give you a certain way to improve your drawing skills.' He then produced a sketchbook – the point was taken. Drawing is a skill that develops with constant practice.

These days there seem to be so many ways to bypass developing your drawing skills. Most of these are related in some form or another to tracing a photograph. Such techniques have been used by commercial artists for many years and are certainly not something I would recommend. At the very least, I regard them as passion killers.

Developing your drawing skills is directly linked to your observational skills and your individual way of seeing, giving you lots of pleasure on your personal artistic journey.

TIMED GESTURAL DRAWING

Gestural drawing is most commonly associated with life-drawing sessions where the model assumes poses for short periods, typically ranging from one to five minutes. The object of the exercise is to capture the pose in the limited time. It forces the artist to observe the entire subject and to simplify the drawing into a few meaningful lines. All gestural work should be done with a time limit as it focusses the mind on the whole and not on bits of the subject.

TONAL GESTURE

Here the artist is more concerned with the light and shade on the subject. Tonal gesture studies can be done in monochrome using charcoal or in colour with pastels or paint. Making small gestural studies is extremely useful before starting larger work. They give you a lot of information on how to light and pose the model, and also allow you to experiment with backgrounds and clothing. The intention of these studies is to gain information. They are also a great way to improve your drawing, painting and observational skills. There is no pressure and they are a lot of fun to do. I normally allow myself twenty minutes and never work larger than 8 x 10in (20 x 25.5cm) on a tonal gesture.

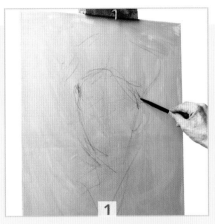

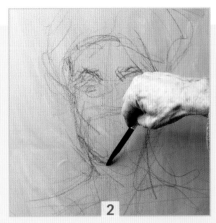

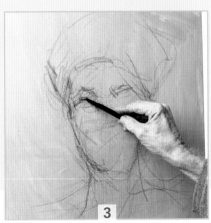

GESTURAL STUDY IN CHARCOAL

The primary purpose of the gestural study is to get the picture in the right position on the canvas, rather than anything else. It should not be highly sophisticated and refined, or you'll feel restricted during the painting itself. I use Nitram Académie Fusains B, a soft charcoal which is ideal because it enables your drawing to be effortlessly corrected or changed. A chamois leather or a kneaded rubber will instantly remove any unwanted marks.

1 Make very sketchy marks, feeling your way around the image. Hold the charcoal quite far back; almost like a brush. Try to keep the marks central to the canvas and use the space. Avoid the temptation to become analytical and establish the features individually.

2 Keep moving; try not to pause. Try to work in a continuous, rhythmical way so that you react instinctively to the sitter in front of you.

3 Develop the overall image; let features emerge as part of the whole.

4 Don't over-develop the study; it should take little more than a few minutes.

RELATIVE SIZES AND ANGLES

For centuries artists have searched for ways of accurately placing the features of their subjects on the canvas. This has resulted in the publishing of many books about the topic and many suggested methods for artists and students to consider, all of which are worth consideration to improve your drawing skills. Two I particularly recommend are:

Sight-size This is a method which has been used and taught for hundreds of years and is still the most taught process in *ateliers* today. Simplified, the process is to place the canvas next to and parallel with the model. Next, you step back so that you can see both painting and subject in one glance without moving your head. The recommended distance to step back is equivalent to at least three times the size of the subject you are painting. From this fixed position you then scale the subject 1:1.

Encajar The word *encajar* is Spanish, meaning 'to encase'. In an artistic context, it is a drawing technique taught in academies around the world. In simple terms, you envelop the subject in a box. Find the top and bottom of the subject, then the width, and create a box around it from which you can find your angles.

There are many other methods of drawing a head, such as those taught by American artists Frank J. Reilly (1906–1967) and Andrew Loomis (1892–1959). Both of these methods focus on accurately drawing the human head based on bone structure and the formation of the muscles. Familiarizing yourself with these methods can give you a greater understanding of what you are looking at and help a great deal in achieving a convincing likeness. I certainly use some of their suggested techniques in my work.

Common proportions of the head

Familiarizing yourself with a few basic common head proportions can be useful, and help to immediately identify where your subject differs from the average. We all have our features in approximately the same place; it is the subtle differences that make us unique. Establishing the thirds between the hairline and chin (shown by the solid lines) will give you a starting point and a relative measurement which can be used to establish the proportions of the head. The bottom of the lower lip usually lies halfway between chin and nose, as indicated by the dotted line.

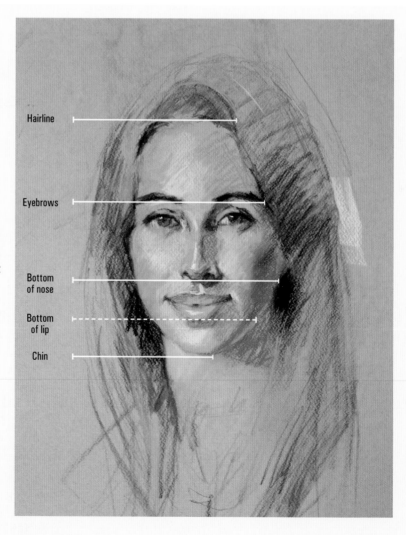

Hairline

Eyebrows

Bottom of nose

Bottom of lip

Chin

> ## Accuracy is important but it is not everything.

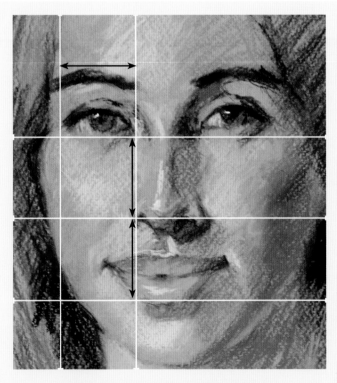

Using features to establish relative proportions

Here I am using an eye's width to establish relative proportions of length. Here, the width of the eye is roughly equal to the length of the nose, and the distance between the tip of the nose and bottom of the lips, for example. Used in combination with the proportions of the head (see opposite), this guarantees greater accuracy.

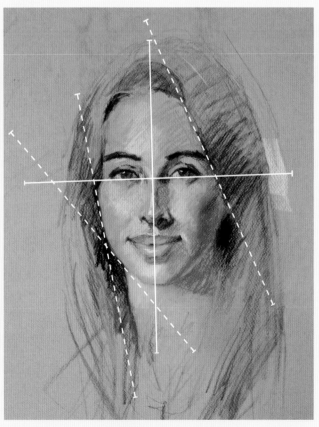

Establishing the central T

The central T is formed by identifying a horizontal line that runs under the model's irises, and a corresponding line that runs perpendicular from the eye line through the centre of the mouth. This 'T', marked with solid lines in the example above, becomes critical when the head is at an angle. I also establish obvious angles, such as where the edge of the face turns toward the chin. These are marked with dotted lines.

MAKING MEASUREMENTS

Your paintbrush can be used to make measurements to help you attain the correct relative proportions of the sitter. The exercises here show a couple of common ways to do so. The purpose of both exercises is to gain accurate information on measurements quickly and clearly..

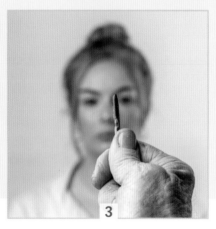

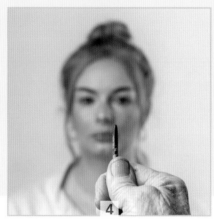

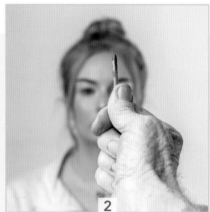

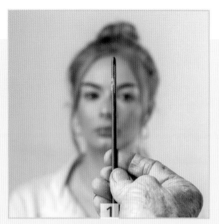

THUMB ON BRUSH: MEASURING RELATIVE PROPORTIONS

This involves holding your brush at arm's length, the end of your brush aligned with one point of your model. You then place your thumb on the brush in line with another point on the model, giving you a particular measurement. This can then be related to another section of the head. It is important to keep your arm straight during this process and one eye closed.

In this example, the end of my brush starts on the model's hairline. This is just an arbitrary measurement. You could instead choose the width of an eye, for example. Personally, I use the brow-to-hairline measurement to establish my big shapes and the width of the eye for smaller shapes.

1 With your arm straight in a fixed position, align the end of your brush with the model's hairline.

2 Place the tip of your thumb on the eyebrow line to establish a measurement.

3 Holding your arm straight, move the end of the brush down to the eyebrow line. Take note of where the tip of your thumb comes to – a point near the end of the nose. From this you can deduce that no matter how big or small you choose to paint the model's head, the distance from her hairline to eyebrows must be the same as from her eyebrows to the end of her nose.

4 The same process can help to identify other distances: here, I can show the distance from the tip of the nose to the chin is also equal to the hairline to eyebrow measurement.

CHECKING ANGLES

Unlike the thumb-on-brush method for measuring, where we are gaining relative information, this technique gives you measurements that can be transferred back to the canvas directly. Depending on whether you are painting or drawing, you can use a paintbrush, charcoal – in fact, anything straight.

We start by identifying any obvious diagonals. The face contains many angles that are useful for the artist: from cheekbone to chin in a full-face portrait is a good example. For profiles or three-quarter poses, the angle of the nose is useful.

1 With a straight arm and the brush handle (or charcoal stick) aimed at the model's head, look for the obvious angles. Here I am looking at the angle from cheekbone to chin and checking the important angle of where the nose protrudes. I am also checking underneath the irises to see if the angle of the head is straight or tilted. This is especially important if the head is tilted.

2 Angle the brush handle (or charcoal stick) so that it lines up with the desired angle.

3 Lock your wrist, and stay standing in the same place.

4 Staying steady, turn back to the picture, swinging the stick in front of the canvas without altering the angle of your wrist.

5 Transfer the angle to your canvas, then double-check by looking back from the drawing to the model.

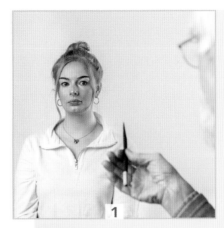
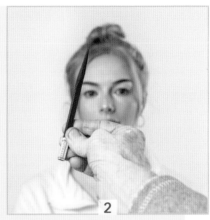
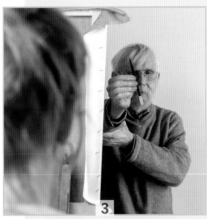

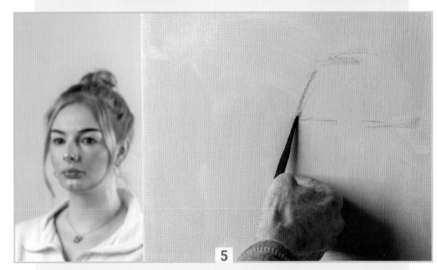

INITIAL CONSTRUCTION DRAWING

The drawing of Lindo on the page opposite illustrates the angles and relative sizes I look for when painting a portrait. I also find dividing the face into thirds to be a very useful way of establishing the proportions of my subject. To do this, I first establish the size of the head on my canvas, then indicate my subject's hairline and the chin line. The space can then be divided into three.

When I drew Lindo, I found that the distance from the bottom of her eyebrow to her hairline was equal to that from the bottom of her eyebrow to the end of her nose; and equal again to the distance from the bottom of her nose to her chin. This gave me a unit of measurement that I could use to establish the other proportions of her head. For example, the distance from the side of her head to the beginning of her ear was two units of this measurement.

I next concentrated on the obvious angles, especially on the dominant side of her face. I also located the corner of the face (the edge where the head turns into the shadow). At this point I had enough information to accurately draw the size of her eye. I used this as a secondary unit of measure to find the more subtle areas of the face.

All of this might sound terribly tedious and mechanical, but construction drawing puts you in control of the basics of proportion, which in turn allows you to focus on the far more important task of painting a fresh, lively portrait of your subject. These points of observation soon become second nature. At the very least, they will stop you from spending hours correcting overworked muddy paintings – I've been there and it's not fun.

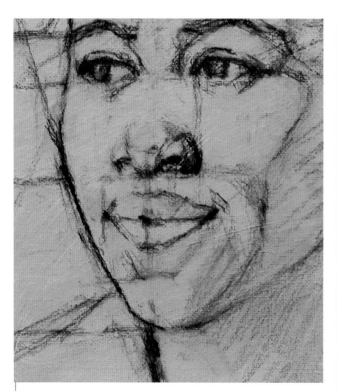

You can clearly see the important corner of the face. This will soften as the painting progresses.

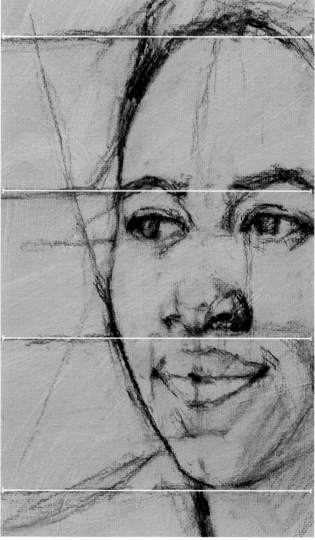

The thirds are highlighted here – though note that these proportions will alter slightly from subject to subject. The change of angle on the left side (our left) is also clearly stated.

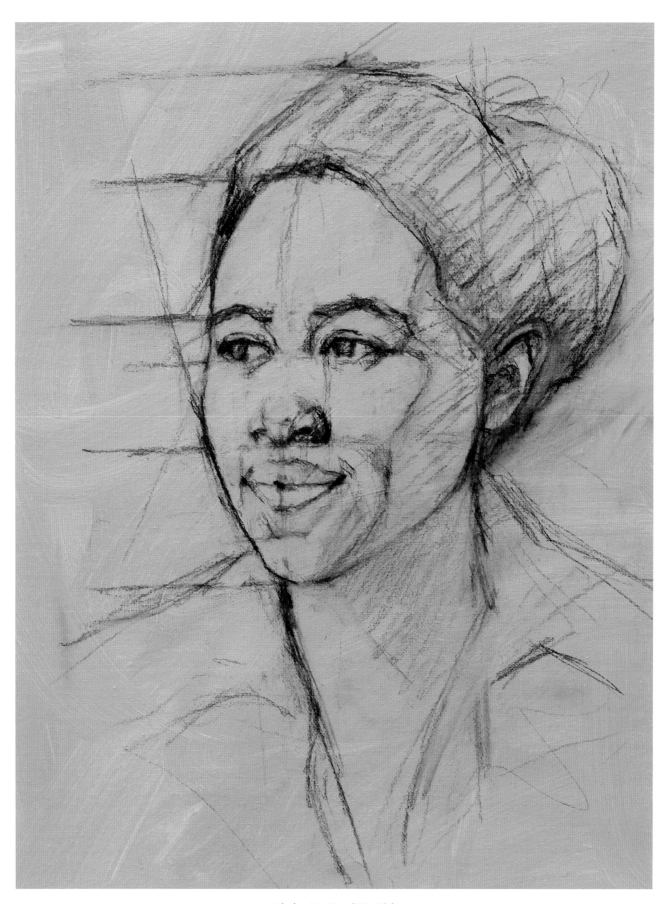

Lindo 51 x 61cm (20 x 24in)

VARIATION IN PROPORTION

In general, a person's eyes will be approximately one eye's width apart; but subtle differences here can make or break your portrait. I always take time to measure this distance in particular very accurately. Consider the painting opposite. Although Nonhle's face fits closely to the proportions of length already discussed (see pages 56–57), her eyes are set further apart than the model used for the proportional sketches on the previous pages. Establishing this subtle distance correctly was critical to achieving a resemblance of my sitter.

Although the features of the human head conform closely to a few basic proportions, it is in the subtle differences that we achieve a likeness of our subject. The difference between eyes being close together or far apart for example is very small – a matter of millimetres – but will have a huge impact on the bridge of the nose and hence the likeness.

The upper lip area, between the end of the nose and top lip, and to where the cheeks wrap around the mouth muscles, also varies subtly from person to person. It is another area that presents the portrait artist with difficulty, because it is an area where most movement and changes of expression occur, and this is coupled with the fact that we normally pick up these changes in expression in our peripheral vision. The subtle differences in distances between the tops of the eyelids and the eyebrows is another area to bear in mind.

Other obvious areas which make an individual instantly recognisable are the shape of their face, their hairstyle, the prominence of their nose or chin and other simple to identify features. With practice, you will be able to immediately observe the important differences between one person and another. In turn, this will help you immensely towards achieving a likeness.

THE POWER OF GESTURE

It is easy to become over-analytical in your approach to drawing. When beginners are given a time limit in a figure drawing session, the work they do in three minutes is almost always vastly superior to that produced when given an hour to do the same piece. This proves to me how advanced our instincts are: we naturally bring order to chaos, and it is important to learn to trust these instincts.

However, this in no way diminishes the importance of the academic processes mentioned above. Some of the greatest portraits were painted by artists who used the sight–size and *encajar* methods. I simply suggest that you don't want to reduce the many advantages of these methods to a form of three-dimensional tracing.

For this project I positioned my easel about 1.5m (5ft) from my subject and began with a quick gestural sketch of my model in charcoal. My focus at this stage was on placement and the size of the head. I then lightened the charcoal sketch by flicking it with a rag, before dividing the face into three parts from hairline to chin and putting in my obvious angles. When I was satisfied that my larger shapes were accurate, I focussed on the smaller shapes, often using the width of one eye as a measurement to establish the placement of the features. Later, when the painting was at an advanced stage, I moved my easel next to the model to better judge my tonal relationships from a fixed position.

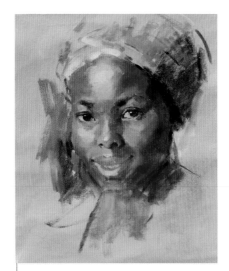

This quick oil gesture sketch helped me to establish value and colour. It measures 20 x 25cm (8 x 10in).

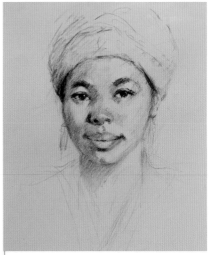

Made after the oil sketch, this value drawing was made with charcoal on larger A2 – that is, 42 x 59.5cm (16½ x 23¼in). It helped me to decide on the fuller-faced pose with the light coming from the right that I used for the portrait opposite.

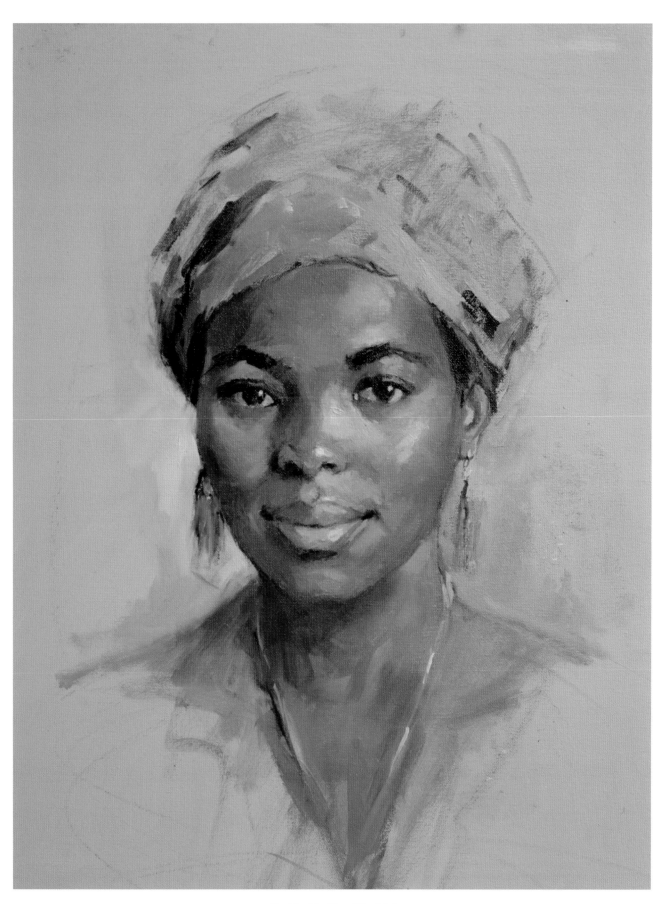

Nonhle 51 x 61cm (20 x 24in)

AVOIDING COMMON MISTAKES

After running many workshops on portrait painting I have noticed how common certain errors are and how consistently these mistakes are made. These errors occur either through lazy observation or painting what you think is there, as opposed to what is really there. The problem with these blind spots – I have had a few myself – is that unless you become aware of them, they become an ingrained habit. In most cases, just being aware of the problem and understanding how it happens is enough.

> "Draw what is in front of you, not what you think is there."

SWINGING TO THE DOMINANT HAND

This error is more obvious when the head is turned (three-quarter pose). People favour either their left or right hand, and there is a natural leaning to that side. If you are not aware of it, this leads to the features leaning towards the dominant hand as you progress down the head, resulting in a very unpleasant distortion which will certainly not please your model.

The cure is simple – draw a central line from the centre of the philtrum (Cupid's bow) of the lip to the bridge of the nose, and stay faithful to that line. You can also take an angle from the brow to the chin which will help.

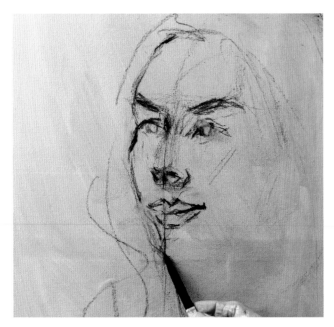

Common mistake

Not being faithful to the central line; here the mouth has been treated as sitting flat-on to the viewer, rather than curving round the face.

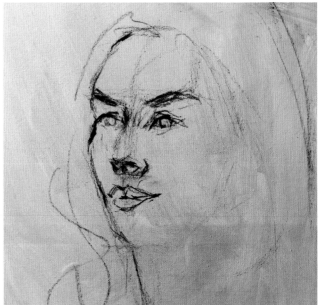

Corrected

The centre of the mouth now lines up with the nostril and where the nose curves by the eye. The left side of the mouth appears shorter than the right, owing to the angle at which the sitter is facing.

MAKING THE NOSE TOO LONG

The distance from the bottom of the eyes to the end of the nose seems to be a common blind spot for beginners, and they invariably make it too long. In my experience, this is definitely the most common error made by students, and more frequently in full-face poses than side-on views. Besides being aware of the problem, two measurements will certainly help:

- The distance from eyebrow to hairline often is equal to the distance from eyebrow to end of nose.

- The length of one eye is often equal to the distance from the bottom of the iris to the nostrils (the actual holes in the nose) – but it's always best to measure to be sure.

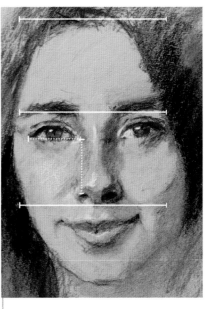

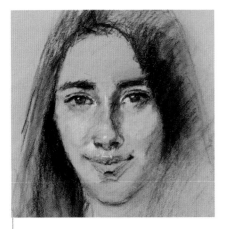

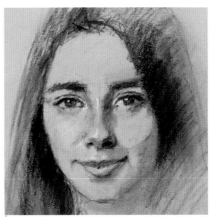

What can clearly be seen when making the nose too long is how it alters the appearance of your sitter and is a guarantee for you to struggle needlessly on the bottom area of the face.

Here the nose is the correct length.

The graphics show the relative proportions I use to ensure the nose is the correct length. The three horizontal lines are vertically equidistant, and the dotted line across the eye is the same length as the vertical line from tear duct to nostril.

IGNORING PERSPECTIVE WHEN PAINTING THE MOUTH

Two common errors occur when painting the mouth. The first is to follow the angle of the upper lip when handling the edge where the lips meet, which results in a more severe expression than normal. The other occurs more in the full face where the mouth is painted on a flat plane, without taking into consideration that it goes around the face.

The best way to solve this problem is to hold your arm straight out, and align your brush or pencil horizontally across the top lip, to take note of where exactly the corners of the mouth are.

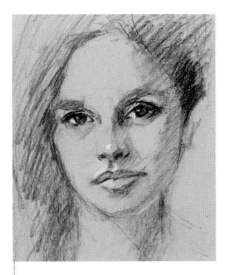

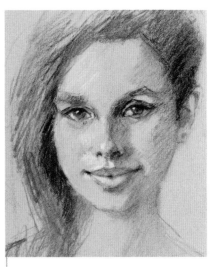

Here, the angle of the top lip does not follow the angle of the central line of the mouth. This not only gives a distorted feel to the expression but goes against the natural perspective of the mouth, making the person look sombre or sad.

This is how it should look – the lines of the mouth follow the curve of the head, creating the correct sense of perspective and form.

Painting skills

The basic proportions of my sitter are established; the head placed on the canvas in charcoal. As I switch to paint, my focus is solely on shapes of tone and colour. Working as broadly and confidently as I can, the early brushstrokes quickly eliminate the initial drawing – which was, after all, merely a guide for paint… This is, by far, the most enjoyable part of the painting. This part of the book looks at both the theory and practicalities of my direct approach to using oils.

In simple terms, I first establish the large shapes, working from dark to light. I paint the dark areas thinly but use a thicker mix when I paint the halftones and lights. It is here that direct painting – that is, wet-into-wet – really comes into its own, with edges blending effortlessly, almost mysteriously, with each other. During this process, details are the last consideration – I look for the shapes of the eye sockets rather than the eyes themselves, for example.

My intention is to observe a shape, mix the appropriate colour and place it accurately, without any alterations, and then move on to the adjoining shape.

TOOLS AND AIMS

I reserve painting any details in a portrait until it is almost completed and even then limit these details to selected areas of emphasis. As I work from large shapes down to smaller, so I start with large brushes and gradually swap them for smaller brushes in an intuitive, natural order. Filbert brushes are my brushes of choice: they give me all the edges I usually require - on those rare occasions that I need a razor sharp edge, I can use a palette knife.

Because of the time limitations, I don't aim to tackle anything more than a head study in a single session. Because I am human and don't always achieve the desired result during a sitting, I will sometimes go back to the painting after the sitting. This may be to correct areas of alignment to or scrape down and repaint an area, but I still do everything I can to retain the freshness achieved during the live sitting. If the painting is a larger study including, for example, the body and hands of the sitter, I will continue with a second and possibly third sitting without going back to what was finished in the first sitting.

ALLA PRIMA AND MULTIPLE SITTINGS

Alla prima describes a direct approach to painting. As the term is most commonly used, the aim is to complete the work from life in one sitting. The charm and desirability of this technique is in the fresh, lively, instinctive brushwork which is impossible to achieve with more layered approaches. John Singer Sargent's (1856–1925) painting of Lady Agnew of Lochnaw is a wonderful example of this.

However, there are many variations of this technique when painting portraits – the most obvious factors affecting the approach being the size and content of the painting. Some of the greatest exponents of this technique certainly did not complete their larger canvases in a single sitting. American artist William Franklin Draper (1912–2003), for example, required five consecutive days of sittings to complete a three-quarter-length portrait including hands measuring 76 x 91cm (30 x 36in).

Nevertheless, as the paint remained wet and workable throughout, this process can still be considered alla prima.

Besides freshness, the direct wet-into-wet approach has other benefits: the time taken to completion is relatively quick and, very importantly, because of the intensity of the situation a natural editing takes place, details being reduced to mere finishing touches on an almost-completed work. There is also a wholeness to the work because the painting is painted wet-into-wet.

Some artists make a few adjustments to their painting after the sitting from photographs and others use the alla prima session merely as a reference for work which is otherwise largely done from a photograph. My own preference is to have the model with me from beginning to end. All of these are valid ways of painting alla prima.

MAKING ADJUSTMENTS

Sometimes after the sitting, I feel that something is not quite right. This normally occurs around the mouth area. Rather than fiddling endlessly (which is guaranteed to make it worse), I scrape down the offending area and call the model in for another sitting. If the paint has started to dry before the second sitting, I use a mixture of half poppyseed oil and half water, shaken vigorously until it becomes a milky colour. I then paint this mixture over the area I am going to work on. As the water evaporates, a thin film of oil is left on the painting, which is a pleasant surface to work upon. I can then correct the offending area without losing the freshness or wholeness of the painting.

Poppyseed oil

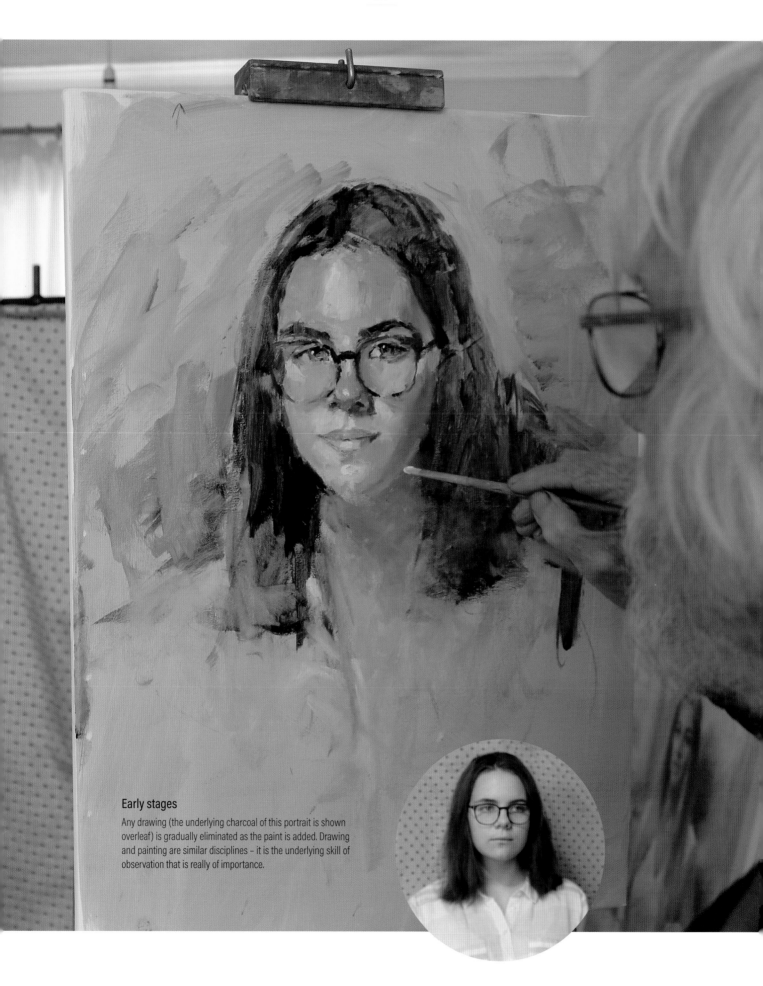

Early stages

Any drawing (the underlying charcoal of this portrait is shown overleaf) is gradually eliminated as the paint is added. Drawing and painting are similar disciplines – it is the underlying skill of observation that is really of importance.

Soft edges that merge with the background are much easier to do when working wet-into-wet.

Details of brushwork on features, where the emphasis is on accurate value.

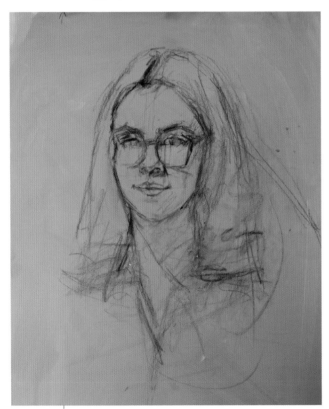

Initial sketch

This charcoal sketch helped me to plan the placement and proportion of the shapes.

PAINTING *ELLA*

The portrait of Ella was painted in a single session of approximately three hours. After doing a layout in charcoal to establish placement and proportions, I then set about establishing a block-in of colours, focusing on values (see pages 80–83) and trying to match the colours in front of me as accurately as possible.

I regard this type of painting as a kind of 'reactionary realism' – although Ella sat still under a constant light source, I had to remain aware of the thousands of little subtle changes which inevitably occur during any sitting. The model is alive and breathing; she blinks and reacts – however subtly – to me observing her. Subtle changes of expression take place all the time: an eyebrow acting independently from the other, perhaps, or the beginning of a dimple appearing and fading.

During occasional conversations, especially during the breaks, I could study the movement of Ella's face, and more tell-tale signs became apparent. My own continual movement also allowed me to see other angles of Ella's head, giving me a three-dimensional image of my model that I had to resolve into the two-dimensional image and angle I had chosen.

One of the biggest advantages when painting alla prima is that there is a natural order of what is important. One hardly notices things that are irrelevant to the task at hand. Working wet-into-wet also creates subtle edges which are impossible to create any other way.

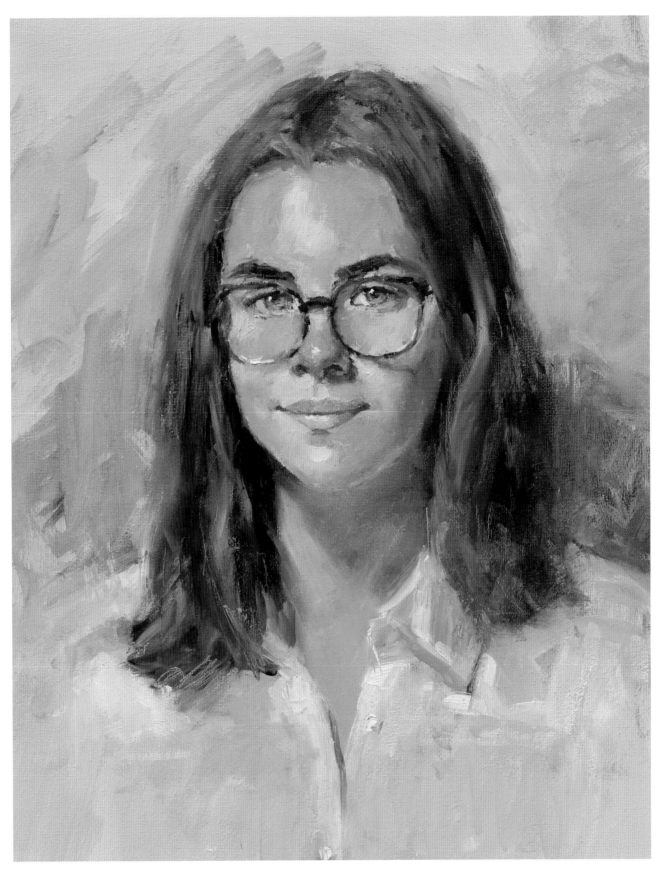

Ella 51 x 61cm (20 x 24in)

PAINTING EDGES

Edges are where two shapes meet and we must decide how soft or hard to make the transition between the two. In painting the corner of a box, for example, the edges will be much sharper and harder than the soft transitions required when painting a cheek as it turns toward the light.

Whilst a logical approach is needed when drawing, in order to establish the positions of your model's features accurately, being sensitive and aware of the myriad of edges in front of you can greatly enhance your painting, opening the door for you to express yourself in a personal way. Your personal view is important.

Subtle manipulation of edges enables the artist to guide the viewer to what they regard as important in their paintings. This is achieved by keeping the sharpest and firmer edges close to the focal point, and softening the contrasts of the secondary areas. How many portraits have been ruined by too many sharp edges in the mouth, for example? This delicate feature is normally seen in our peripheral vision and should be painted subtly, unless the sitter has gone out of their way to make his or her mouth the focal point (such as with bright red lipstick).

It is much easier to discern edges when observing one's subject in three dimensions – hence the advantage of working from life. In portraiture, every edge lies on a spectrum, but I try to break down this variety to just four types for clarity – hard, firm, soft and lost. We look at these overleaf, but first it is useful to have some techniques to help us identify and select edges.

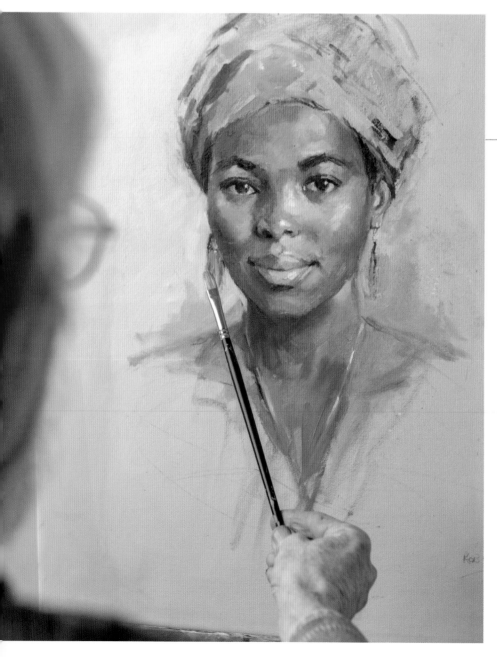

A successful portrait will include a variety of different qualities of edge in order to direct the viewer's eye, ranging the whole spectrum from clean, sharp, obvious breaks to smoky, lost borders.

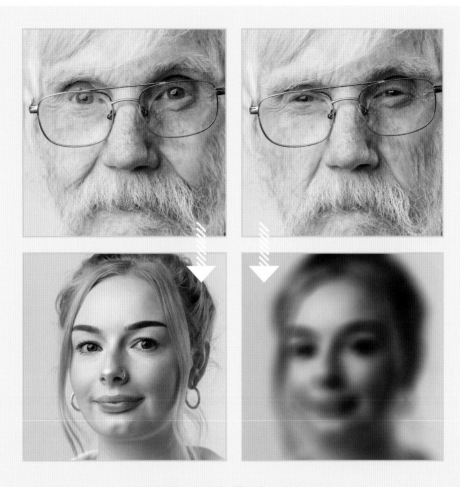

Squinting immediately simplifies a face, taking away the sense of identifiable features and leaving simple shapes and values.

IDENTIFYING AND SELECTING EDGES

Squinting your eyes so that your vision is diffused by your eyelashes helps enormously and simplifies what you are looking at into clear understandable shapes.

You immediately become aware of your sharpest hard edge. The next edge I look for, which is not always obvious, is the lost edge. I can then compare the other edges in my subject with these extremes, deciding which are firm and which are soft. I am also aware that areas of sharp contrast that appear away from my focal point will pull the viewer's eye to them, weakening what I am trying to convey. Being selective is important.

Accurate drawing is the grammar and punctuation of portraiture, whilst sensitive handling of edges is more akin to poetry.

TYPES OF EDGE

The intrinsic nature of what you are looking at will determine the edge you are looking at. The edge of the corner of a box in direct sunlight will be sharper than that of a ball, for example. The edge of the blonde hair of a child will be softer than the cheekbone of an elderly gaunt man.

HARD EDGES

Hard edges occur in high-contrast areas, such as the shadow side of black hair against a strongly-lit cheekbone, or the cast shadow of a nose against the cheek – as in the example below. Direct sunlight and spotlights also create hard edges, especially in cast shadows. Having the highest contrast in value, these are the last edges to disappear when you squint your eyes – only becoming unclear when your eyes are almost shut.

I paint hard edges with direct brushstrokes (no blending) with a filbert brush. If I require the edge to be still sharper, I would use a palette knife.

FIRM EDGES

When painting portraits in natural light (north light) you will find more firm edges than hard edges, generally speaking. Where they differ from hard edges (see left) is that the contrast between the edges is not as great. By squinting at your subject, take note of which edges hold and which ones disappear.

Firm edges are painted directly, with very little blending. The use of these edges helps to retain the form of what you are painting. A perfect example of this is when painting the head with one main light source. The edge of the shadow and halftone against the light as it describes the form can clearly be seen to be firmer as it describes the temple and cheekbones.

Hard edge
The shadow cast by the nose creates a hard, unmistakable edge against the cheek, sharply delineating the nose itself.

Firm edge
While not as marked as the hard example to the left, there is a clear distinction in value on the temple.

SOFT EDGES

Soft edges occur in many situations in portraiture, owing to as the intrinsic nature and form of the face. For example, the hair and the roundness of cheeks in a young child are generally soft. Minimal contrast also creates soft edges. Blonde hair against a pale background will naturally result in soft edges, for example. Another situation that creates such edges is lighting: diffused light, such as natural north light, creates soft transitions.

We might also intentionally depict edges as softer in order to create a particular effect. Away from our focal point, edges should be kept soft. This simulates how areas in our peripheral vision become softer and more out of focus than things we are looking at directly.

Soft edges are created when two different values are painted wet-into-wet and a soft filbert brush is used to bring the edges together. This has to be done gently, as too much blending will flatten out the form.

LOST EDGES

'Less is more' may be a cliché, but it certainly applies to painting. Lost edges are areas in the painting where two values or totally different colours are blended together so that the edge between the two can't be seen. I paint these wet-into-wet with a large filbert brush, softly mixing the two edges until the desired effect is achieved.

Finding areas in your painting where the edge can be successfully lost – that is, depicted minimally – can add strength and charm to the final painting. These areas create more interest because the viewer fills in the missing edges themselves. Whenever an edge is lost, it strengthens and emphasizes other parts of the painting; more defined areas become more evident through contrast with the lost edges.

Soft edge
While showing differentiation in value, the transition is much more gradual than in the firm edge example opposite. Note also how the hard edge of the shadow cast by the nose against the cheek compares with the soft edge, where the cast shadow meets the nose.

Lost edge
There is almost no difference in value between the background and hair in this lost edge; the distinction is only apparent through hue and quality of stroke.

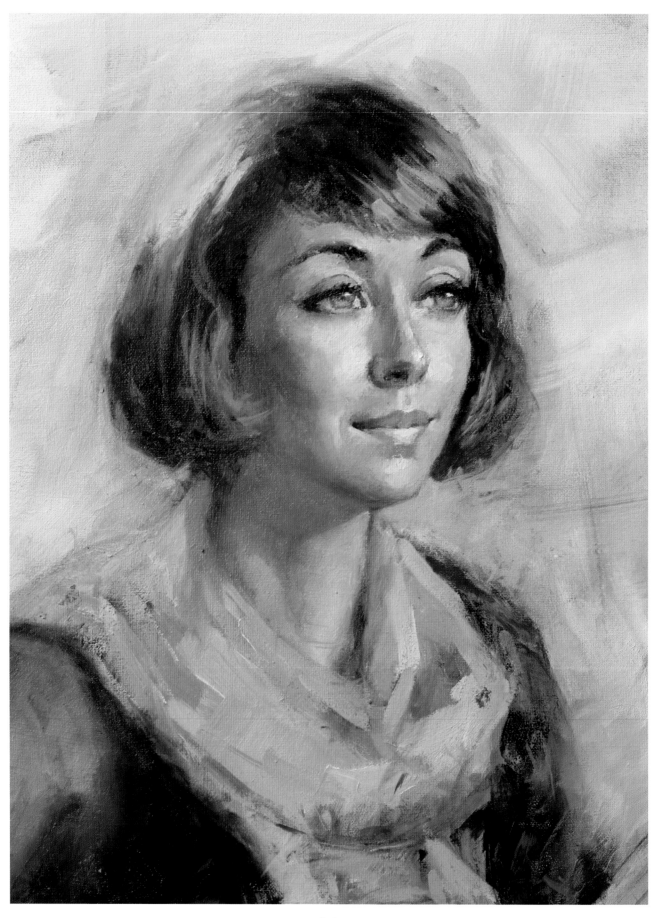

Detail of Faye

The full painting can be seen on page 137.

The broken, soft edge where the hair meets the background adds emphasis to the firm edge of the cheekbone.

PAINTING *FAYE*

This detail focusses on the edges used around Faye's head, as it It is a good example of how variation in edges can help to direct the eye. By manipulating edges from lost to firm, the artist can guide the viewer to what they regard as important in the painting.

The lighting on my model was a soft cool light. Note how we come from the side of the face in shadow to the light through soft, subtle transitions of edges. Sensitivity to the edges in your paintings can add an amazing amount of strength to what you are trying to convey.

Although this portrait has few, if any, really sharp edges in the head, there are a large variety of firm to lost edges as the hair and background come together. I achieved this in the painting by squinting my eyes while studying the model and comparing one edge against another. For example, where the dark hair meets the cheekbone (our right-hand side) the edge against the cheekbone is a lot firmer than where the hair meets the background. The light on the cheek is also a lot more important, so I intentionally softened the hair against the background. Breaking up this edge helps to add emphasis to the cheekbone. Sharp edges on both sides of the head would have drawn attention away from the focal points – the cheeks and eyes.

The values where the back of the head meets the background and where the second warm light was illuminating the head are very similar. This allowed me to totally lose that edge while still retaining the feeling of solidity. Lost edges can add a lot of strength to the more prominent parts of your painting.

Where the hair meets the background the values are similar. Even though there is a colour change, the edge is lost.

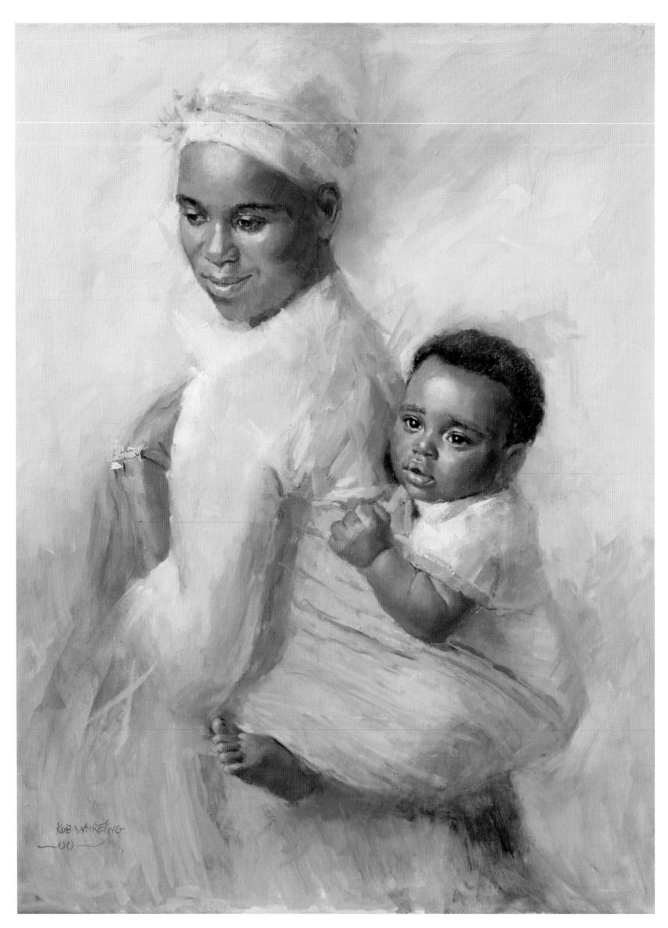

Mother and Child 61 x 76cm (24 x 30in)

PAINTING *MOTHER AND CHILD*

Unlike a camera, our eyes can only focus on one or two edges at a time, so selection of edges is important – and particularly so in compositions such as this. The models for this portrait posed in the studio, but the background was manipulated to emphasize what I regarded as important.

In this maternal study, keeping the values of the background high in key added an outdoor feel to the painting. The soft contrasts between background and subject allowed me to lose many edges, such as the mother's headscarf, and indeed contrasts are essential to guiding the viewer to areas of interest: the soft edges down the mother's back stop abruptly at the dark, sharp contrast created by the baby's head. This shows that lost and broken edges are an important tool for the artist. Not only do they leave the viewer to fill in the gaps but they also add strength to the selected points of interest.

Lost edges along the mother's shoulder allow the viewer to fill in the gaps.

There are many edges down the baby's back, going from lost edges to firm edges, but no contrasts that are strong enough to compete with the head.

Values

Values refers to the degree of lightness or darkness we see in our subject. These are sometimes referred to as tones, although the term tone can also be used when referring to colour. Values are always the degree of lightness or darkness.

CAPTURING LIGHT

From the dramatic portraits by Rembrandt van Rijn (1606–1669) to the amazing effects of sunlight by Joaquín Sorolla (1863–1923), history has shown us how possible it is for artists to convincingly capture the light on their subjects. Having a clear visual image of the light on your subject before starting will go a long way to understanding conservation of values. After all, without light we cannot see anything.

In portraiture – or indeed, any painting – what we are doing is creating shapes of shadows, halftones and light that, when placed correctly and with the right values, resemble what we are looking at.

IDENTIFYING VALUES

When we squint our eyes as we look at our subject (see page 73), we simplify what we are seeing into clear understandable shapes of light, halftones and shadows. The clear separation of these values is invaluable in allowing us to capture a convincing feeling of light.

Squinting also gives us greater control over our pupils, which otherwise constantly adapt and change as we look at something. For example, the longer we look into a darkened doorway, the more we see. This is fine if we don't want to trip over bits of furniture, but when it comes to painting, a simple dark shape may be all we need. The same applies when painting a portrait – the longer we look into the shadows the more we see, and trying to paint everything will certainly weaken our painting.

Throughout my painting, I regularly squint to check that the basic relationship of the shapes is correct, but I open my eyes fully to check the values – squinting is important for the relationships of values, but it also darkens them.

VALUE SCALE

Values range from absolute black to pure white in a continuum, but for years artists have simplified the vast number of values in nature to a number of segments – typically nine – between the extremes of black and white.

The advantage of creating these artificial distinctions between closely-related values is that it helps us to correctly identify a particular value. This does not mean that you are obliged to use all of them in a painting, of course – only that everything we see can be painted within this range.

You can make your own value scale from a spare offcut of board or canvas, as shown to the left. Start from pure titanium white paint for point 1 (at the top of the image), then add proportionally more ivory black to the mix until you have pure black at point 9.

USING A VALUE SCALE

By holding your value scale up to your subject, you can quickly identify the values on certain areas of your subject. Some artists use a value scale on their palette, too – this helps you to judge the values accurately when mixing colours.

1

2

3

4

5

6

7

8

9

CONSERVATION OF VALUE

When looking at black and white photographs of portraits done by some of the Old Masters, it amazes me how few values they used; often restricting themselves to using just two values in the shadow areas and two or three values in the light areas. These four or five values were joined together using soft halftones, accents and highlights.

Over-modelling the light areas normally brings values belonging to the shadow area into the light areas, therefore weakening the effect of light and shade. The same applies to the shadows, where over-modelling – painting reflected light too strongly, for example – dilutes the shadow area and flattens the form.

Rather than a change in value, artists including John Singer Sargent (1856–1925) and Anders Zorn (1860–1920) used changes in colour temperature to create the illusion of form. The reason for this is that using too many values to describe the form weakens the illusion of light – and in turn weakens the overall painting.

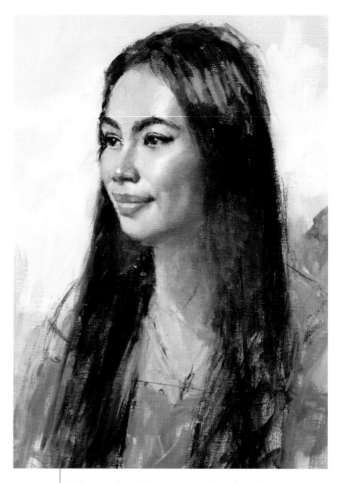

In this monochrome image, you can see how few values were used. The portrait of Wan can be seen in colour on page 105.

Top left: A hard edge is created owing to the strong contrasts in value between hair and brow.

Top right: The shadow on the neck and hair are close in value, resulting in a lost edge.

Bottom left: Compare the firmer edge on the cheek and the transitions on the cheek itself: the former has greater contrast in values than the latter.

THE RELATIONSHIP BETWEEN VALUES AND EDGES

In places where the values in a painting are close – for example the shadow of the neck against dark hair – the edges should be soft and, in some cases, can almost be lost. This can add strength to the form: finding the edges where the transition between the shapes is almost indistinguishable can increase the strength of the firmer contrasts. The reverse is also true – sharpening obviously soft transitions will weaken your painting.

What lies beneath the surface also helps to determines how hard or soft your edges are. For instance, the transitions between light and dark on the cheekbone will be a lot firmer than the soft changes of values required to paint the cheek itself.

The light that is on your model is also a factor in determining the hardness and softness of these transitions. Direct sunlight and spotlights will create lots of sharp contrasts, especially in cast shadows.

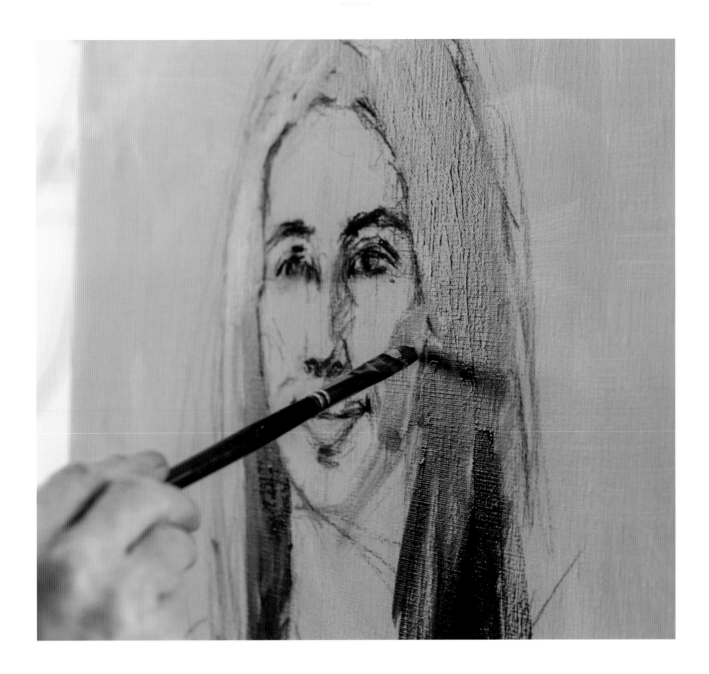

ESTABLISHING A VALUE RANGE

Having something you can compare with at the outset is key to establishing an accurate tonal range. After establishing my proportions and placement of the head, my next step is to paint a convincing tonal range. The initial drawing will be almost totally obliterated during this stage – but remember that it is only a guide; you can easily recover it if you need to.

I scan my subject, searching for the darkest dark, then paint this area as accurately as I can. This is my key to establishing the next value, moving as accurately as possible from dark to light. The aim of this is to produce a broadly painted tonal study that clearly shows the effect of light on the head. This study can then be used to inform the portrait itself.

TONAL BLOCK-IN

With a proportional and placement drawing completed, this exercise shows you how I block in the tones using a large brush, and trying to paint the shapes as accurately as possible. Starting from the dark values, we work upwards into the light.

1 Having decided on the key of your painting, mix a dark from burnt sienna and ultramarine blue. This should be equal in tone to the darkest value you want in your painting – in this case an eight on the value scale (see page 81).

2 With the dark areas in place, work up to the midtones. As you start placing them, you can use the value scale to help – but try to rely on the judgement of your eye first and foremost.

3 Continue working up the values as you block in the image, building up to the lightest tints.

4 As you continue to refine, concentrate on getting the values correct across the image.

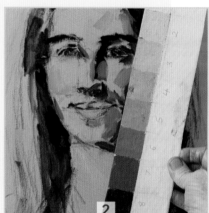

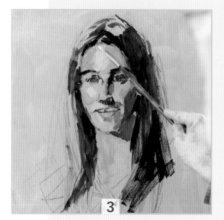

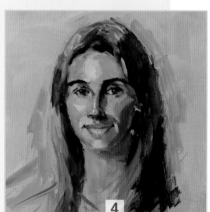

TIP

I squint my eyes during this process, which helps me to avoid paying unnecessary attention to detail.

REFINING THE TONAL BLOCK-IN

I start to focus in on the subject while the paint is still wet, adjusting the shapes and subtle changes in value. This helps me to develop a clear mental image of what I would like to capture and to start the finishing process by particularizing areas of importance.

I normally bring the eye region into focus first. Apart from giving me a definite benchmark against which to judge the finish of the rest of the painting, it is also the area we generally focus on when looking at someone.

Just as you can identify edges more easily with your eyes half-closed, so squinting at the subject will help you to see the clear separation of values and their relationship to one another. It does, however, darken what you are looking at – so open your eyes or use your value scale to judge how dark or light they are.

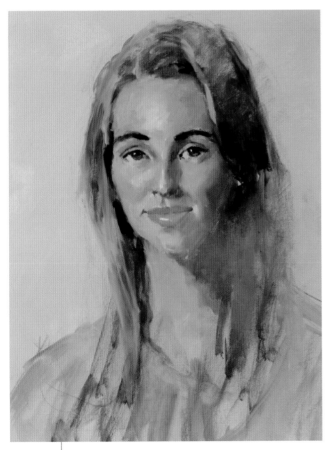

After the block-in of values is established I begin the refining stage, starting by finishing the eye region.

Cara 51 x 61cm (20 x 24in)

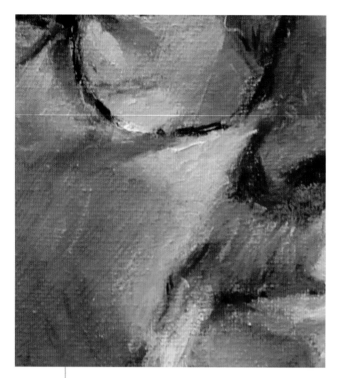

One can see the strong colour as the halftone joins the light planes of the head. Note also that the value of the cast shadow of the nose is clearly darker than the form shadow of the head.

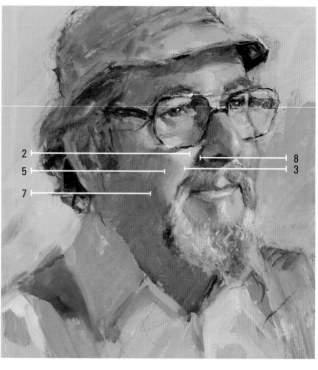

From left to right: shadow accent, shadow, halftone, light, highlight.

PAINTING *JIM*

The lighting used to illuminate Jim's head was a warm incandescent bulb which gave me warm lights and cool shadows. I began by trying to simplify the values into five distinctly separate values – two in the shadow, one halftone and two lights. The only other thing which might be needed would be more halftones rather than full value changes.

A note on halftones: these subtle areas connect the light to the shadow and can add a lot to the portrait. Although similar in value, they can change a lot in colour, with the tone connected to the shadow being almost devoid of colour and conversely being rich in colour where it meets the light.

It is a good idea to identify which values you are looking at in the different areas of light, highlight, halftone, shadow, reflected light and shadow accent. Be careful of highlights becoming too isolated in places where they describe the form. The highlights here stand out a lot and are crisp in areas such as the catch-light in eyes or light reflected in spectacles. They are also strong on the tip of the nose.

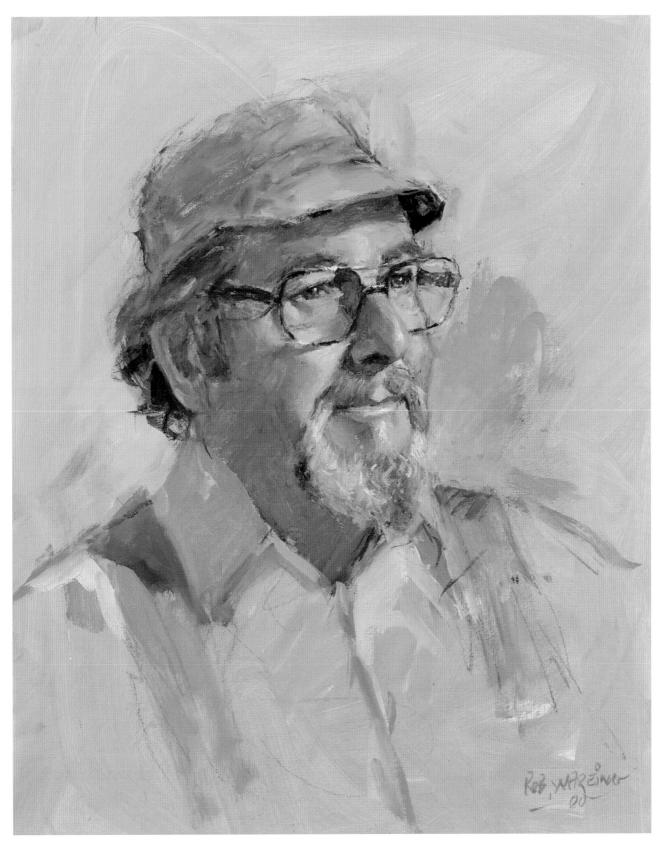

Jim 51 x 61cm (20 x 24in)

A colourful character who was fun to paint.

Where the shadow meets Nonhle's dark hair, one can clearly see how soft and almost indistinct the edge is. This gives strength to the edges closer to the planes of light.

PAINTING *NONHLE*

In this painting, the shadow areas, including the hair, are painted with almost no value changes. This gives more interest to the light areas where maximum colour and detail occur. I have also kept the left-hand side values (our left) close together. The combination of this adds a lot to the light on the forehead and cheekbone, which were my points of interest.

Most of the changes in values occur as the form turns towards the shadow on the forehead and the cheekbone.

From left to right: shadow accent, shadow, halftone, light, highlight.

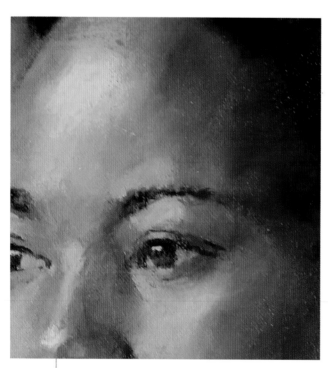

Detail of forehead and cheekbone. The values here change smoothly from light to dark.

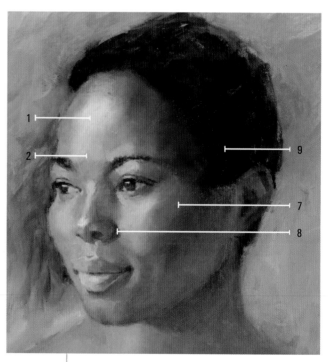

This annotated detail from the finished painting shows that the lightest value is not, as one might expect, the model's white clothing, but instead the reflection of light on her skin.

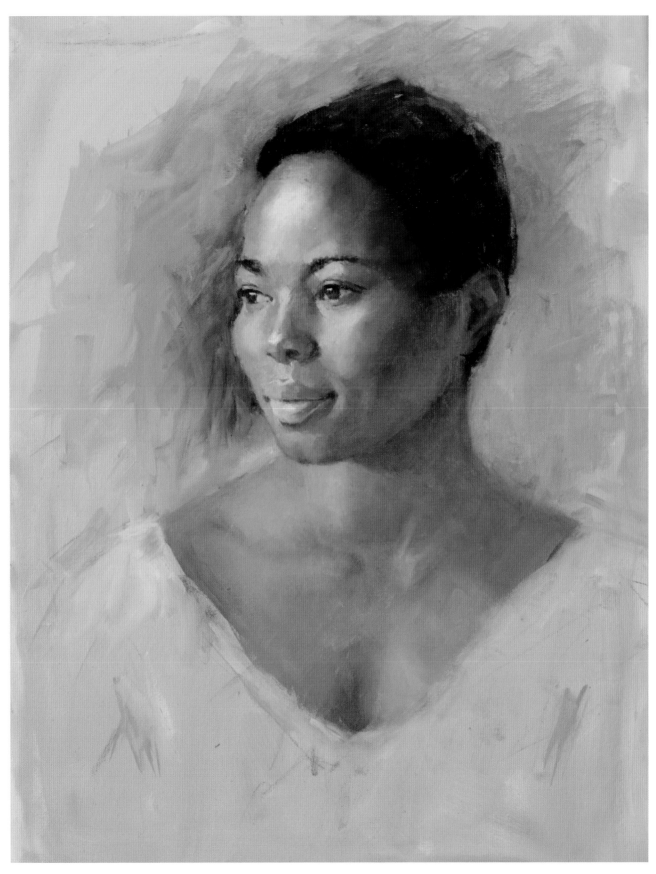

Nonhle 51 x 61cm (20 x 24in)

Colour

The complexity of colour theories, and the millions of hues to be found in nature, are the subject for another book. Our task, when painting a portrait from life, is to look at our subject, mix the appropriate colours and place the colour on the canvas accurately. To achieve this you have to be familiar with the colours on your palette and how to mix the colour you see.

COLOURS ON YOUR PALETTE

The colours used by artists vary, with some artists using very few colours and others needing twenty or more. Anders Zorn is said to have only used four colours (white, black, vermillion and yellow ochre) which is remarkable when one looks at his beautiful colourful paintings.

My palette is shown opposite, with the colours laid out ready for use. This is how I always lay them out, which means picking up a particular colour has become almost instinctive. Note the larger amount of titanium white: I use one pool for pure white, and the other for mixing.

I find this selection enough for almost any subject. Extra colours I use on rare occasions for particular effects are cerulean blue and ultramarine violet.

Ultramarine blue This is a cool transparent colour useful in creating rich darks and subtle greys. Some manufacturers call this French ultramarine.

Burnt sienna A warm transparent brown, very useful for shadows and halftones in portraits. When mixed with ultramarine blue, it creates rich darks.

Alizarin crimson A cool transparent red, very useful in creating flesh tones. When mixed solely with ultramarine blue – that is, with no white added to the mix – this creates an intense black.

Raw sienna A neutral earth colour with a low tinting strength. It is very useful for creating subtle flesh tones when mixed with white and red.

Yellow ochre An opaque yellow earth colour. When mixed with white and red it creates lovely flesh tones.

Cadmium red light A warm opaque red, useful in creating warm flesh tones.

Cadmium red An opaque red useful in creating flesh tones.

Cadmium yellow deep A warm opaque yellow used for painting extremely warm areas.

Cadmium yellow light An opaque yellow that I use in combination with one of the reds and white for the lightest areas of a portrait.

Titanium white My first choice of white. It is very opaque, has a high tinting strength, mixes easily and has good coverage.

COLOUR, PREPARING AND MIXING PAINT

When painting portraiture, we rarely use paints unmixed and pure. Instead, we mix the paints in combination to better represent what is in front of us. Generally speaking, we can get very close to what we see by mixing only one or two colours together. If a third colour is used, it is used very sparingly to slightly adjust the tone we are painting. Using too many colours tends to result in a muddy, dirty colour.

Manufacturers of paint have done a lot of work for us to ensure consistency and variety in tube-bought colours. Having particular identifiable hues available – alizarin crimson and cadmium red light rather than just 'red', for example – means that we can control what we include in a mixture more precisely. For example, if we know we want to use an orange-tinted red in a mix, rather than a purple-tinted one, we know to use cadmium red light rather than alizarin crimson.

My first consideration when trying to match a colour I see in front of me is to determine how dark or light it is – that is, to find the value. Having a definite starting point (normally the darkest dark) accurately established on your painting is helpful to achieve this, as it allows you to judge accurately the value you are mixing by comparing it with the starting point.

Once I know the value of the area I want to paint, the next consideration is how warm or cool it is. In other words, does it lean towards red, yellow or blue? In combination, assessing the value and temperature will enable you to mix the correct hue. The word hue is used in different ways. In the manufacturing of paint it is associated with using different pigments to achieve the same colour (almost like making generics of well-known brands of household products). Here, it is used to identify what colour family the shade you are looking at is: does the greyed-down mixture tend toward the yellow family or the red family?

If, in trying to mix exactly the hue of the flesh tone on my subject, I have used yellow ochre, cadmium red and white to bring it to the correct value but it still appears too strong in colour, I have two options. The first is to add a touch of blue to the mixture, which will grey it down – this is because the blue is the complementary colour to orange (which is produced by the mix of red and yellow). Mixing a touch of the complementary into any colour will neutralize its intensity. The second option is to switch from cadmium red to alizarin crimson (which has blue in it). I could also change from yellow ochre to raw sienna (which is a much duller earth yellow) to achieve the same thing. Experimenting with mixtures will teach you a great deal.

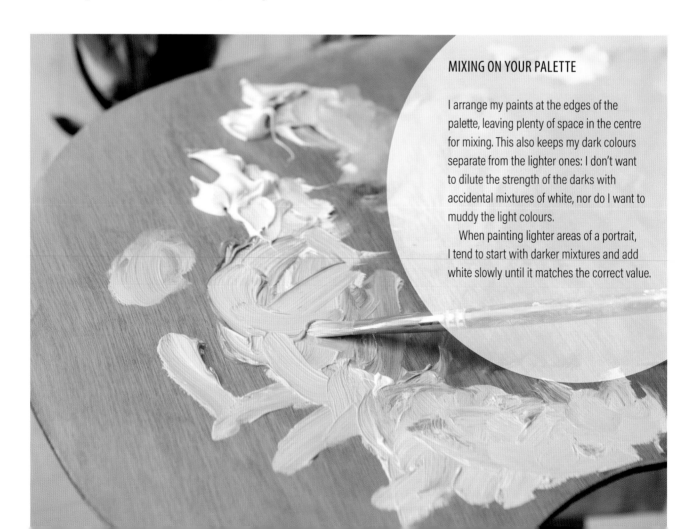

MIXING ON YOUR PALETTE

I arrange my paints at the edges of the palette, leaving plenty of space in the centre for mixing. This also keeps my dark colours separate from the lighter ones: I don't want to dilute the strength of the darks with accidental mixtures of white, nor do I want to muddy the light colours.

When painting lighter areas of a portrait, I tend to start with darker mixtures and add white slowly until it matches the correct value.

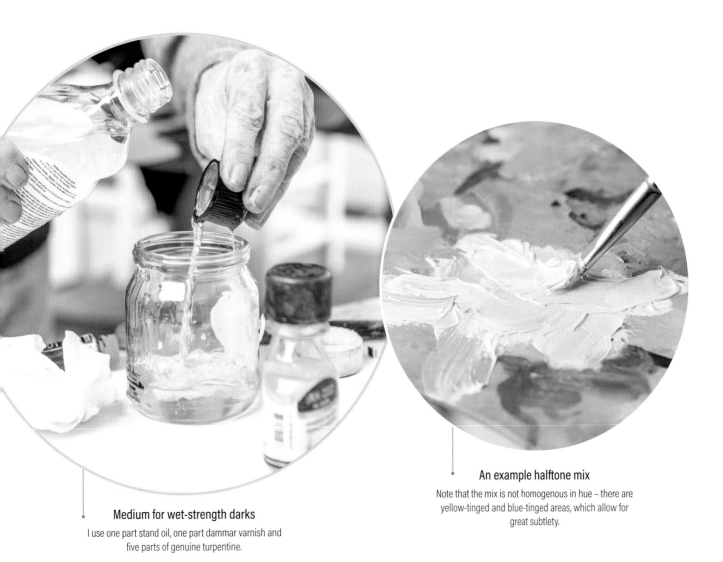

Medium for wet-strength darks
I use one part stand oil, one part dammar varnish and
five parts of genuine turpentine.

An example halftone mix
Note that the mix is not homogenous in hue – there are
yellow-tinged and blue-tinged areas, which allow for
great subtlety.

PAINT CONSISTENCY

To set me on track at the beginning of a painting, I establish a few darks. You can more easily lay thicker paint over thinned-down paint than the other way around, so these initial darks are almost always thinned-down with turpentine to a watery, wash consistency in order that they are not too bold and overpowering, and to ensure that the darks retain an element of transparency. Without this, the finished result can appear flat.

As explained on page 25, I also use a medium very sparingly in dark areas where there is no white paint (for example dark hair or black clothing). These areas dry quickly and go 'flat', which makes them appear lighter, encouraging you to repaint them. This is not a good thing, as darks are more lively when transparent. The medium keeps these dark areas at wet strength; that is, they stay as they were painted throughout the whole painting.

When painting other areas, I use the paint undiluted, straight from the tube. I find these mixes have enough oil in them and dry more slowly, so no medium is required. When painting halftones and lights in particular, I mix the colour on the palette thickly, combining it with white, so that when I place the required stroke on the canvas a generous amount of paint is deposited – I want to avoid a scratchy, tentative appearance which can come from putting too little paint on the canvas.

The image above right shows the consistency for which I aim when painting halftones and lights. It is fluid enough to apply cleanly, while remaining stiff enough to retain interesting textural brushmarks.

COLOUR TEMPERATURE

In general terms, we can regard colours such as orange and yellow as being warm colours, and blues and violets as cool colours. An obvious example of this would be my impressionistic painting of blond-haired children in white clothing in sunlight (see page 106), where warm sunlit areas are painted with subtle tints of yellow and orange, while the shadows are painted with blues and violets, thereby creating a convincing feeling of sunlight.

When painting portraits you are not usually dealing with such obvious colours, the exception being if you are deliberately trying to emphasize colour for a particular effect, as in the aforementioned *Children in a Sunlit Rock Pool*. However, understanding which colours are warm and which are cool is useful when preparing mixes. Let us look at the temperatures of the colours on my palette as well as some other commonly used colours:

Reds Alizarin crimson (cool – it has blue in it); cadmium red (neutral); cadmium red light (warm – it leans towards orange when white is added)

Yellows Cadmium yellow pale (cool); cadmium yellow deep (warm); lemon yellow (cool)

Blues Ultramarine blue has red in it (warm) while cerulean blue has yellow in it (cool).

This is useful information, but such a list is simplified, as these definitions only really work for the colour in isolation. When you use it within a painting, the colour temperature must be examined in relation to the other colours present. Just as you can have a high-key painting in which the shadow areas are still relatively light in value (see page 40 for more on key), you can have a painting that is overall warm or cool in temperature. For example, in a painting made with lots of very cool hues, cadmium red – nominally neutral – will appear relatively warm.

This has always been a subject of much debate and many contradictions, particularly about which blue is warm in comparison with other blues. We look at how the temperature of the light affects the choices of paints to use in more detail on page 98.

MIXING FOR VALUE

As a student, I was fortunate enough to attend a workshop with New York master painter Daniel Greene (1934–2020). We were given very large palettes and for the first hour of every day we were required to pre-mix various colours to a value scale of five. Starting with burnt sienna on its own, for example, we slowly added white until we had five clear values, then burnt sienna and blue, then burnt sienna and alizarin and so on. After that it was raw sienna, then the other colours.

At the time I was not sure what I was learning and found this daily process tedious. Years later, I found a more comprehensive version of this process in the excellent book *Alla Prima* by another master painter, Richard Schmid (1934–), and this helped me to recognize the value of the exercise.

Apart from being an excellent way of familiarizing yourself with the colours on your palette, making colour charts that show value is a great exercise which shows how few colours you need to match the shapes that you are looking at. Begin with burnt sienna on its own, then ultramarine blue, then try different combinations of the two: firstly burnt sienna dominant, then ultramarine blue dominant. You can then try different colours: burnt sienna and alizarin crimson, for example; then raw sienna and alizarin crimson and so on. All you need is a few small, cheap canvases. This practice will teach you an amazing amount about colour and value and will help immensely in mixing to match exactly what you see.

Altering the value

The top row shows burnt sienna on its own in the leftmost square, and four tonal variations made by gradually adding white establishing a value range of five, from dark to light.

The bottom row shows ultramarine blue in the leftmost square and four tonal variations achieved by gradually adding white.

MIXING FOR TEMPERATURE

The approach detailed above can also be used to create value scales which vary in temperature, another of the qualities that makes a specific colour. Temperature value scales are a good way to explore the qualities of a particular paint colour and how it relates to others.

When two complementary colours (orange and blue are complementary colours) are mixed, they create grey. These greys do not need to be true neutrals; they can be adjusted to be warmer or cooler. In the charts below, we have created warm and cool greys using just the two colours burnt sienna (an orange brown) and ultramarine blue. You can clearly see how varying the proportion of blue affects the temperature of the colour.

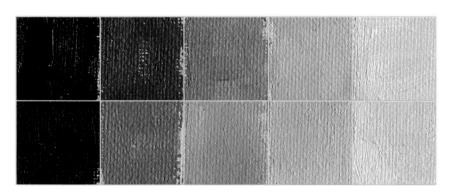

Altering the temperature

The top row of swatches here shows various values of burnt sienna and white, but I have added an equal proportion of ultramarine blue. This shows the process of establishing five values and what is possible when mixing a second colour.

By making a small increase in the amount of blue to the same mixtures, I have created a cooler blue-grey set of values in the bottom row.

USEFUL MIXES

The colour of flesh – the most varied, evocative and common mix you will use in portraiture – is created through various mixtures of the primary colours: red, yellow and blue. By combining these in different proportions, we 'grey down' the intensity of the colours until they match what we are looking at.

If you had to mix the three primary colours together in equal proportion, however, you would undoubtedly end up with a muddy grey. By varying the proportions of these colours we are able to accurately record the colours we see – giving a redder or bluer hint to the mix.

TINTING STRENGTH AND INTENSITY OF COLOURS

A mixture of alizarin crimson and raw sienna can give you a beautiful flesh colour when white is added. However, if you mix them in equal proportions, the alizarin would dominate to such an extent that you would hardly notice the raw sienna. This is because the tinting strength of the alizarin crimson is far stronger than that of the raw sienna.

The grid of values pictured below illustrates this. The top row of values is made using just raw sienna and the row beneath just alizarin crimson. In the third row I have mixed equal proportions of raw sienna and alizarin crimson. Note how little difference there is between the second and third rows.

In order to achieve the required flesh colour, the alizarin crimson can be used in much smaller proportions. In the fourth row here, I have changed the proportions to more than ninety per cent raw sienna and less than ten per cent alizarin crimson. This shows how dominant one colour can be over another.

This is part of the reason why I suggest that you avoid using the cheaper students' quality ranges, and instead spend a little more on artists' quality oil paints. Brands such as Talens Rembrandt, Michael Harding and Winsor & Newton Artists' Quality range produce colours which are vastly superior in terms of intensity.

Colour dominance

MIXES FOR SKIN

This grid shows various colour mixes I find useful when painting portraits, and there are many more you could try. Here, only two colours have been used and then gradually lightened by adding white to create a value scale of five, as explained earlier.

The top row shows mixes of ultramarine blue and burnt sienna with increasing amounts of white; the second row shows burnt sienna and alizarin crimson; the third raw sienna and alizarin crimson; the fourth yellow ochre and cadmium red; the bottom row cadmium yellow light and alizarin crimson.

Creating grids like this will certainly help a lot in understanding what is needed to reproduce what you see. You can try others such as cadmium red and raw sienna or cadmium yellow light and cadmium red – and many more besides. Remember that the proportions you use of each colour can vary the tone considerably, owing to the intensity.

The grid should be looked at as a guide to help when trying to match the colours of the shapes you see and not a formula that you apply to every situation. It is not against the law to add a third colour to the mix but you will find that two colours will get you very close and that if a third colour is required it will be just a touch.

A	B	C	D	E

Example mixes for skin

Dark shadow: a mixture of burnt sienna and ultramarine blue with a little white. I have kept the burnt sienna dominant as the shadows are warm. It can be seen on the top row of the grid above as B.

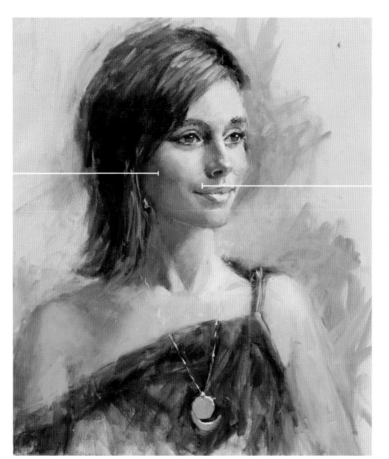

Shadow halftone: the lighter shadow on the upper lip can be seen on the top row of the grid above as E.

LIGHTING YOUR MODEL

Whatever you are painting will be affected by the light that is illuminating it. For example a red block in warm light, such as direct sunlight, will appear orange. If we placed it in cool light, such as next to a north-facing window on a blue sky day, it will lean towards the purple in the light area.

Like anything else, the colour of flesh depends largely on the light that is illuminating your subject, and the light on your subject will therefore affect the colours you choose. The photographs below clearly show how different the colours of the same model's face appear under different light sources, demonstrating how crucial the quality of the light is to your portrait. Generally speaking, if the light on your model is warm, then the shadows will appear cooler by comparison. Conversely, if the light is cool then the shadows will appear warm. This is a basic starting point when observing your model. There are other factors which can make this more difficult to observe, such as ambient light in the room and the colour of the model's clothing, but the underlying principle remains the same.

Direct sunlight and normal incandescent (tungsten) bulbs create warm light on your model, while north light from your studio window is cool – this is more obvious on a clear day than on a bright but overcast day. This must be taken into account when looking at colour.

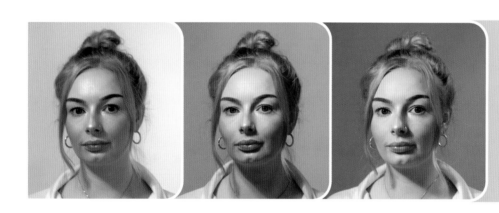

From left to right: single cool light from left; single warm light from left; combination of warm light from left and cool light from right.

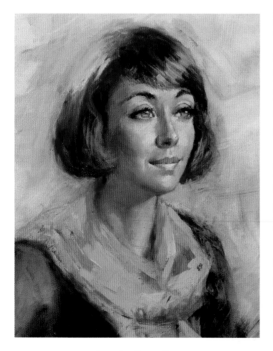

A cool palette: *Faye*

The majority of her face is in cool light, but the light illuminating the back of her head is warm.

Since colours are hugely influenced by the light, the answer to the earlier question, 'which blue is warm – ultramarine or cerulean?' therefore needs another question answered first: 'what is the temperature of the light?' If you were painting a blue beach hat in warm direct sunlight, you would use cerulean blue in the lighter areas and ultramarine in the cooler, violet-like shadows. The reverse would be true in a cool light situation: ultramarine in the lighter areas and cerulean in the shadows – especially on an overcast day where the light appears almost violet-grey.

In the portrait of Faye (left), posed in a cool light, the lighter areas of her face were painted with mixtures of alizarin crimson and cadmium yellow light – both cool – with a touch of ultramarine blue. The shadows were warmer by contrast, using warm burnt sienna as a dominant colour, slightly neutralized by ultramarine blue. The warm light illuminating the back of her head was painted with cadmium yellow deep and white.

The majority of the portraits I paint are arranged to give me the desired patterns of light and shade, and with a definite temperature of light: either a cool north-facing natural light or a warm incandescent bulb from my portable lamp. This is because I find artificial lights that mimic natural daylight tend to flatten out the form and eliminate the subtle halftones. Incandescent (tungsten) artificial light, although warmer than daylight, is the closest possible alternative I have found for giving me the effects I want in my portraits. I have not experimented with all the lights available, but if it were possible, I would paint all my portraits in north light.

INDOOR AND OUTDOOR LIGHTING

Soft diffused light, typical of indoor lighting, is often the lighting of choice when painting portraits as it describes the form of the head in a most natural way. Too much emphasis on reflected highlights, or painting them too light and too colourful, will dilute the shadows and weaken the effect of light in your portrait.

Diffused light is very different from direct sunlight, particularly in terms of intensity. The colours you see outdoors are much more intense than in the studio. The difference between warm and cool also becomes more obvious. For example, picture a cast shadow of a tree against a sunlit white wall. It's easy to see that the shadow has blue and violet in it and the sunlit area has touches of warm yellow in it. As we paint with pigments, not light, it is impossible to match all the tones you see exactly, so colour and tone must be exaggerated, especially in the reflected lights. This is why such paintings are more powerful when viewed in colour and look quite flat in black and white. When painting in direct sunlight – the strongest, most powerful light source – the aim is to capture the feeling of this light.

COLOURS IN SUNLIGHT

Direct sunlight is extremely warm in colour and is also the strongest light source. It has also been the source for many wonderful paintings – Sorolla's beach scenes and Zorn's outdoor nude studies immediately come to mind. Painting outdoors, trying to capture the effects of sunlight, can be an enjoyable learning experience.

Vibrant colour and colour temperature really become important when painting outdoors: in the painting to the right, one can see how bright and light everything appears. In situations like this, instead of thinking about light and shadow areas, it is easier to think in terms of separating the dominant light (direct sunlight) from the secondary light (reflected light and ambient light).

In bright sunlight, we are working with pigments on canvas trying to capture a light source so strong it has us reaching for our sunglasses. To make matters more difficult, our lightest light is white, which is cool – and when we warm it up by adding a yellow or orange to it we darken it slightly.

The sun is always moving, so we have a limited time (not a bad thing); then there are distractions like the wind, onlookers and insects (have I put you off yet?). Still, it is possible to paint a convincing painting of subjects in sunlight. Indeed, the challenge is so enjoyable that, once you start, you will find it difficult to stop.

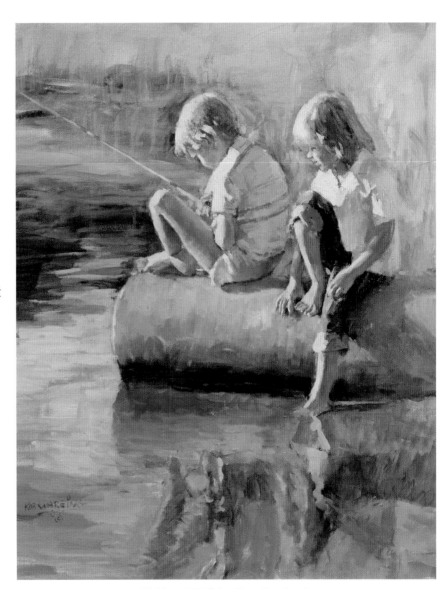

Fishing at St Michael's-on-Sea Beach
51 x 61cm (20 x 24in)

PAINTING *THULISILE*

Thuli has been a favourite model of mine for a number of years. This painting was done from a pastel I had painted of her a few years ago. The goal here was an exercise in warm and cool light. I posed her next to my studio window, her head strongly lit by the cool light. I then lit the shadow side of her face with a warm incandescent bulb from my studio lamp. These two lights created the shadow down the centre of her face. Both lights were positioned approximately forty-five degrees above the model.

One can clearly see mixtures of warm paints – cadmium red light, yellow ochre and burnt sienna – in the large portion of her face bathed in the light from my lamp. The edge light on the left-hand side, meanwhile, is rendered using cool paints: alizarin crimson, ultramarine blue and a touch of cadmium yellow light with white.

The pastel had been completed in a single sitting on a middle tone pastel paper. For this oil I worked directly on a white canvas as I felt that raising the key would enhance the colours more.

This close-up emphasizes the warmth of the light from the right-hand side. The shadows are cooler and can be seen more down the centre of the face and where the form turns.

COLOUR MIXES FOR SHADOWS

There are many combinations used for mixing colours to establish shadows in painting portraits. I predominantly use a mixture of ultramarine blue and burnt sienna. I find that these colours together in different proportions give me the subtle low -intensity tones I see in shadows. Apart from burnt sienna and ultramarine blue, I sometimes add a touch of alizarin crimson or cadmium orange. These colours are used sparingly.

Traditionally, portraits are painted with the model illuminated by one dominant light source which simplifies what you are looking at into three distinct areas, namely, light, halftone and shadow. As the shadow is on the opposite side to the dominant light source, too much colour in this area will weaken the effect of light on your subject. If one sees strong colour in shadows, it is always in the reflected light.

For example, the light bouncing of Thuli's bright orange scarf results in orange hints seen in the shadow area of the face. Reflected light must be handled with care because it can easily dilute the strength of your shadows.

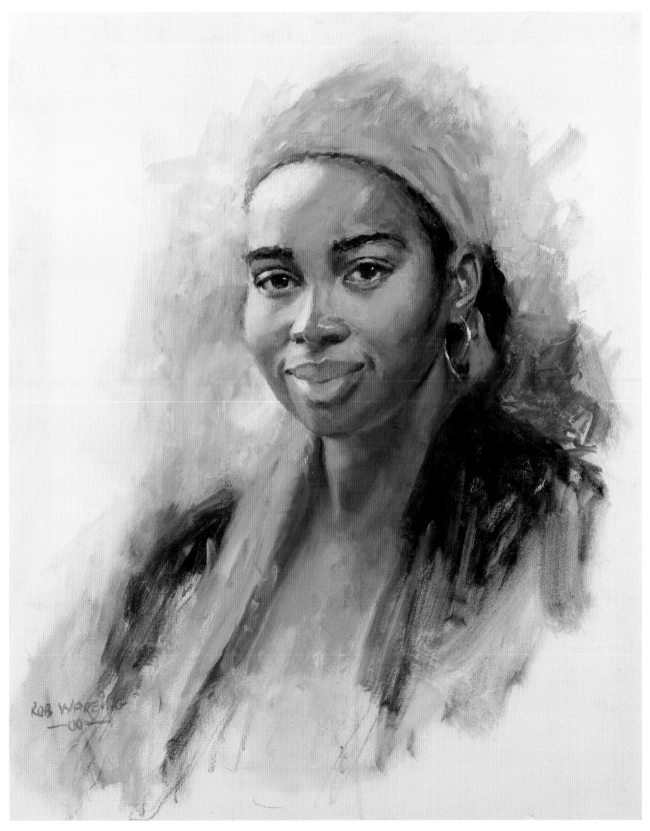

Thulisile 51 x 61cm (20 x 24in)
Here, the majority of the head is in warm light with the
edge light (our left) being cool.

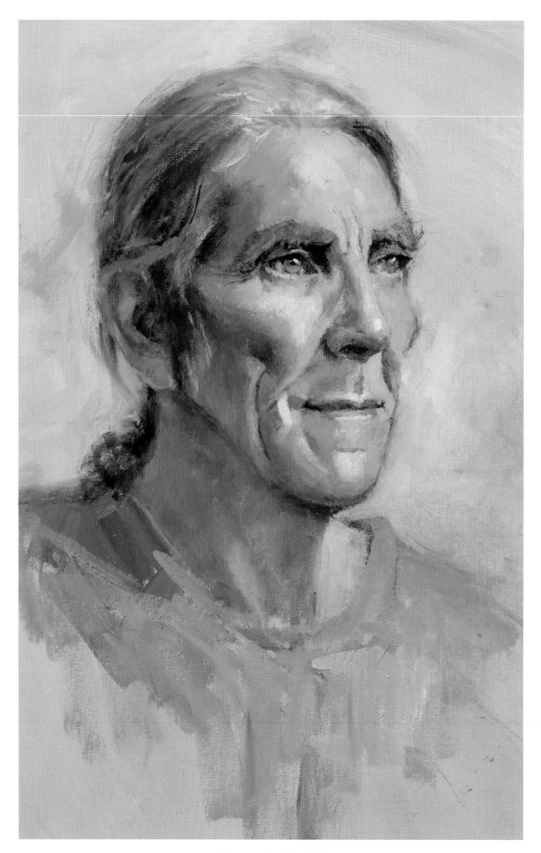

Keith 51 x 61cm (20 x 24in)

PAINTING *KEITH*

Keith was painted next to a studio window in natural diffused daylight (in the northern hemisphere you will need a north-facing window or in the southern hemisphere a south-facing window). This yields cool lighting giving cool light areas and warm shadows. The basic colour combinations are illustrated below.

Keith has a healthy outdoor complexion. The natural cool light helps to avoid washing out the midtones or creating harsh shadows, as can happen under direct sunlight.

The shadow side of his face appeared very warm, so I painted these shadow areas (A) with burnt sienna neutralized with a little ultramarine blue. I added a small touch of orange to the shadow mixture for the subtle reflected light picked up on the jaw line. You could use cadmium orange for this, or mix an orange yourself from cadmium red light and cadmium yellow deep.

In the shadow accents (B) – the hollow below the cheekbone and eye sockets – alizarin crimson and burnt sienna were used to retain the warmth of the shadow areas.

The strongest colours were found where the light halftone (C) meets the light plane, most notably at the top of the cheekbone, which I painted with burnt sienna and alizarin crimson with a touch of cadmium red light. On the forehead (E and F), I used burnt sienna and raw sienna, varying the proportions for different areas. All of these warm tones were important to set off the cool colours used for the lights. In these light areas (D), I used mixtures of cadmium yellow light and alizarin crimson with white.

Below the nose the shadow side of the upper lip appeared a lot cooler than the other shadow areas, showing the beginning of stubble. I used burnt sienna and ultramarine blue (with blue dominant) and lightened with white to the appropriate value to achieve this.

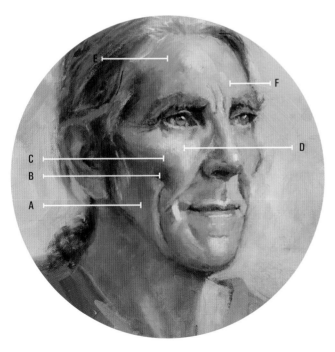

Shadow (A) This is a mixture of burnt sienna neutralized with a little ultramarine blue. and lightened with titanium white. It is painted thinly.

Shadow accent (B) This is a mixture of burnt sienna and alizarin crimson painted thinly.

Halftone light (C) This is a mixture of burnt sienna and alizarin crimson lightened with titanium white to the appropriate value, painted thickly.

Cool light (D) This is a mixture of alizarin crimson and cadmium yellow light lightened with titanium white to the appropriate value and painted thickly.

Warm halftone light (E) This is a red-dominant mixture of raw sienna and alizarin crimson, lightened with titanium white.

Light (F) This is a yellow-dominant mixture of raw sienna and alizarin crimson, again lightened with titanium white.

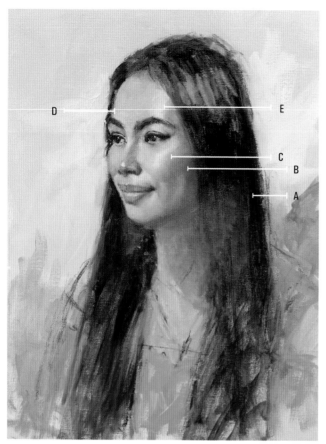

Black (A) This is a mixture of ultramarine blue and alizarin crimson, painted thinly to keep the darks rich.

Shadow (B) This is a mixture of burnt sienna and ultramarine blue lightened with a little titanium white and painted thinly.

Halftone light (C) This is a mixture of burnt sienna, cadmium red light with a touch of yellow ochre lightened with titanium white to the appropriate value and painted thickly.

Light (D) This is a mixture of yellow ochre and cadmium red light lightened with titanium white and painted thickly.

Highlights (E) This is a mixture of cadmium yellow deep and cadmium red light lightened with titanium white and painted really thickly.

PAINTING *WAN*

I used a warm incandescent light – a tungsten lamp – to illuminate Wan's features, giving warm light areas and cool shadow areas. As with the portrait of Keith (see page 102), the shadow areas are burnt sienna neutralized with ultramarine blue, but here the blue is dominant, giving a cooler result.

We also have the strongest colour at the points where the halftone light (C) meets the light, such as the cheek. Although slightly cooler than the light areas, it is still very warm, with burnt sienna, cadmium red light and a touch of yellow ochre being used. This was lightened with white to the appropriate value.

The lights (D) are painted with yellow ochre and cadmium red light and the highlights (E) with cadmium yellow deep and cadmium red light lightened with white. The principle behind this is that as the head turns towards the warm light, these areas become progressively warmer.

The highlights are where the light source itself is reflected back. Such reflected highlights must be painted subtly so that they do not become too isolated from the light planes. In the shadows, which are blue-dominant, I have added a touch of alizarin crimson to give a slightly violet touch to them. This complements the warm golden look of Wan's complexion.

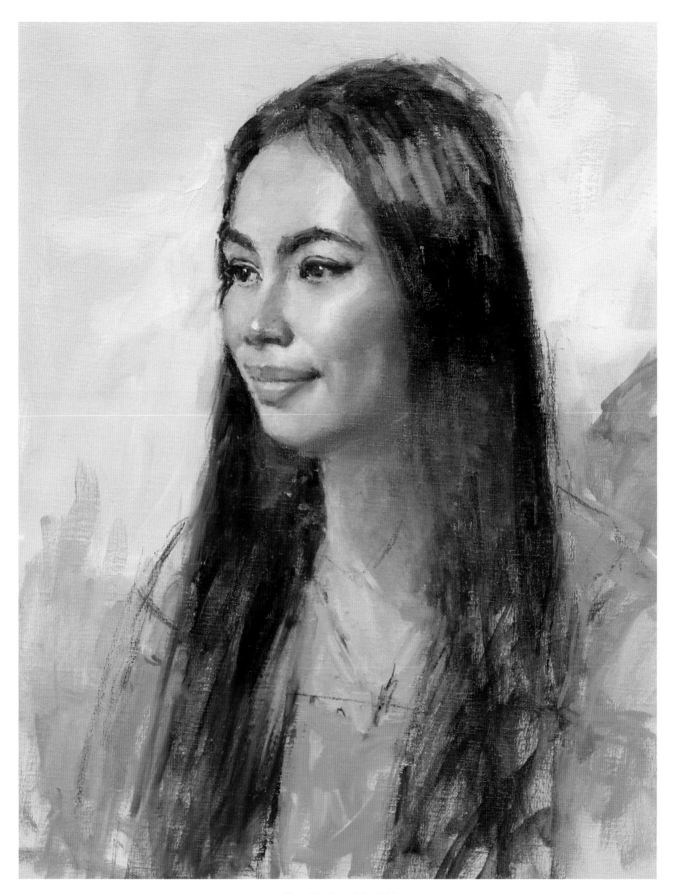

Wan 51 x 61cm (20 x 24in)

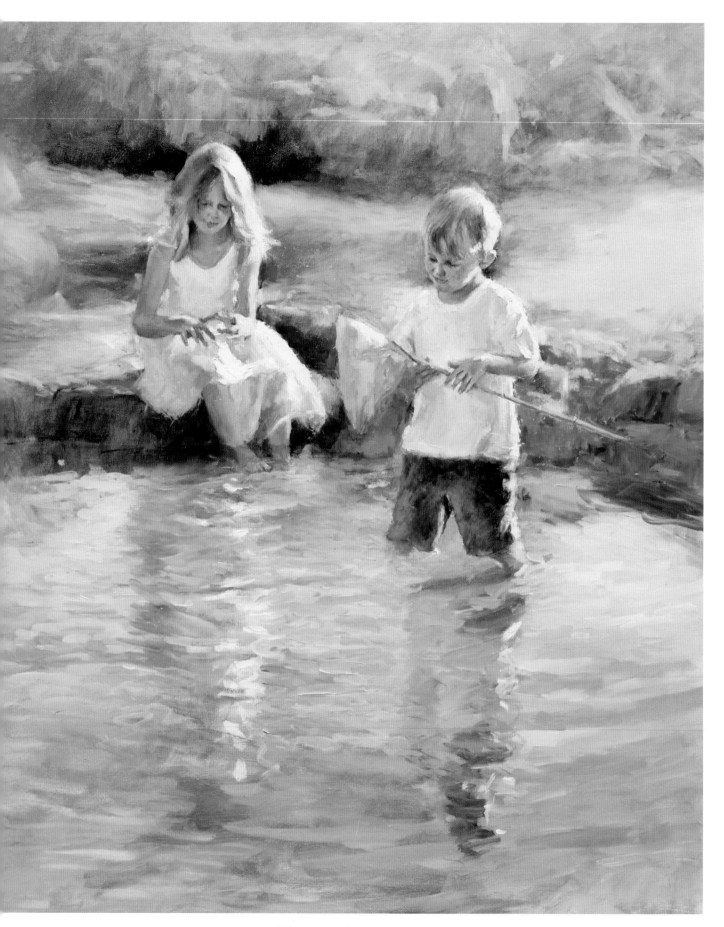

Children in a Sunlit Rock Pool 76 x 91cm (30 x 36in)

Here you can clearly see that warm yellows are
used in the hair to emphasize the warmth of
the sunlight.

Note how close in value the reflected light from
the water on the girl's chest is to the lightest sunlit
effects on her dress. The main contrast is colour.

PAINTING *CHILDREN IN A SUNLIT ROCK POOL*

Painting children at play has long been a favourite subject of mine
and over the years I have received many portrait commissions of
this nature.

This painting shows another unique quality of sunlight – the quality
of the reflected light. With bright light bouncing off everything around
it, the reflected light is lighter than you might think. This becomes a
critical area when trying to depict a convincing feeling of sunlight. If
you paint the ambient reflected light too dark you lose the effect of
sunlight even though you increase the contrast between light and dark
(it starts to look like a spot-light effect). If you instead paint these areas
too light, the contrast between the sunlit areas and bounce-lit areas
can be lost and your painting will start to look flat and dead.

Here the edges separating the direct sunlight from the reflected light
were kept firm and loaded with pure colour. With these in place, I then
painted the reflected light as light in value as possible using violets,
blues and subtle greys. The direct sunlight on the white clothing is a
very light mixture of cadmium yellow and white while the reflected
light areas are loaded with subtle variations of light colours.

When studying the capturing of sunlight in the work of past masters,
such as Joaquín Sorolla, you can clearly see that this problem was
resolved by their use of colour and edges – painting the reflected light
areas remarkably light, then gradually darkening and intensifying the
colour as it reached the sunlit areas where the edges between the two
are firm.

Preparatory study

This project will walk you through painting a preparatory study – that is, a painting to prepare you for a more complete painting. This study is what I would typically aim to produce in a single sitting, and will provide many valuable lessons.

Skin is, of course, very important to portraiture, and so the emphasis here is on using the lessons on mixing (see pages 92–97) in a practical, applied demonstration. For that reason, we'll assume you have your initial drawing sketched out. If you'd like to follow along exactly to practise, you can copy the charcoal drawing below – but I would encourage you to use your own sitter. You might also try painting a self-portrait, as this is a good way to study skin tone closely.

The proportional drawing you make on the canvas should not be too embellished, but should take into account the angle of the head, its placement on the canvas, the width of the face in relation to its length and the positioning of the features.

If you are working from your own study or doing a self-portrait for this exercise, make sure that light and shadow can clearly be seen. You will see below that I have indicated the corner of the face in shadow, establishing that the light is coming from the left. Do bear in mind that the drawing will be totally obliterated with broad brush work as you progress, so don't get too fussy with it – see it merely as a starting point, and concentrate instead on getting the skin tones right.

▶ ## You will need

CANVAS:
51 x 61cm (20 x 24in)

BRUSHES:
Size 10, 8, 6, 4 and 2 filberts, and size 4, 3, 2 and 1 soft filberts

PAINTS:
Burnt sienna, ultramarine blue, alizarin crimson, titanium white, raw sienna, yellow ochre

OTHER MATERIALS:
Prepared medium (see page 25), genuine turpentine, white spirit or mineral turpentine, glass jars, rags and paper towels

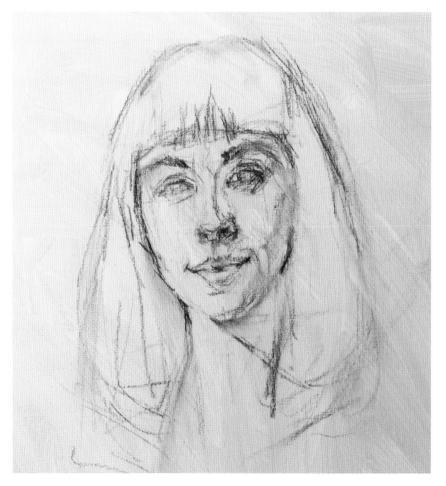

Drawing
The portrait drawn out, ready for skin tones to go on.

STAGE 1: SHADOWS

We work from dark to light. In this case, the model's dark hair gives an easy-to-see dark note: it is black on the shadow side of her hair. The dark note can be used to compare with how dark to paint the other shadows. This is one of the few times I use a medium to keep my dark areas at wet strength (see page 93). You can see from the steps that I slosh the paint on with broad strokes; almost carelessly. My only consideration is the dark note at the right-hand edge of the face where the ear would be.

Once the dark note of the hair is in place, the next step is to mix the shadow at the corner of the face. For this, we mix burnt sienna and ultramarine blue with a little white and place it next to the dark of the hair. Stand back and focus totally on the relationship between the dark of the hair and the shadow.

Key aims

- *Identify the dark note*
- *Establish the shadows on both hair and skin*
- *Avoid refinement – work loosely and quickly.*

1 Place burnt sienna, ultramarine blue and alizarin crimson on your palette, along with titanium white.

2 Using the medium quite liberally to allow it to flow – and importantly, to keep it transparent – mix the three colours together to create a rich dark.

3 Use this mix to paint in the hair with a size 10 filbert.

4 The same hues in a person's hair are always present – to a greater or lesser extent – in their skintone, so we use much the same mix for the areas of skin in shadow, adding just a hint of titanium white to vary it. Don't treat the skin, neck or hair as completely separate – it's all part of the broader portrait. Add some hints of light on the hair using a similar mix as the skin.

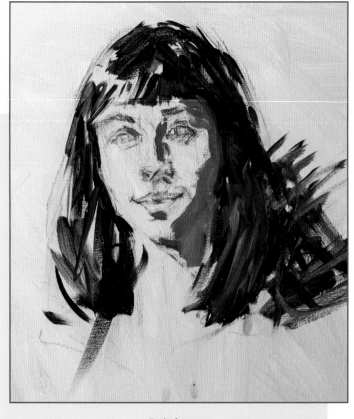

End of stage 1

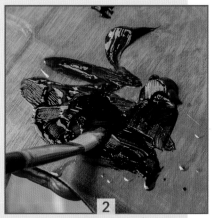

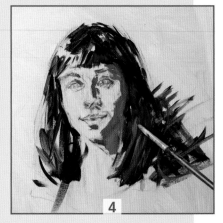

STAGE 2: MIDTONES

When satisfied that the values are correct in the darks we can move on to the halftones. Start with the light halftone which describes the cheekbone – this is normally the strongest colour, and easier to see than more subtle areas. For this, mix burnt sienna and alizarin crimson with white and judge the value and hue against the already established shadow areas. This mixture sets us up for the next stage, painting the light side of the face with a lighter version of the mixture.

Key aims

- *Establish the midtones on the skin*
- *Create distinction between the left and right sides of the face*
- *Create and retain a sense of light coming from the left.*

End of stage 2

1 Make a mix of burnt sienna, alizarin crimson and titanium white.

2 Use this to paint the halftones coming out of the shadow into the light on the right-hand side of the portrait. You may find it helpful to switch down to a smaller brush, such as a size 8 or 6.

3 On the side facing the light, the same hue is used, but – being in the light – it will always be a little brighter and slightly washed-out. Add some titanium white to the mix to achieve this.

4 When painting the side in the light, be careful not to over-model this area, or you will kill the effect of light.

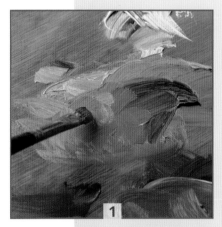

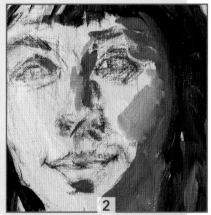

STAGE 3: LIGHT AREAS

Using the mixtures on the palette alongside some warm yellows, we now establish the lighter shapes of the face. We use smaller brushes as we paint the lightest parts, allowing for finer marks as we work up to the final highlights.

Key aims

- *Complete the tonal range*
- *Keep your eye on the overall effect as you paint details*
- *Apply the paint thickly.*

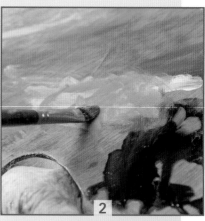

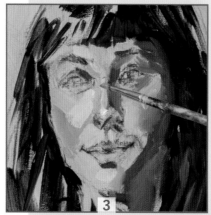

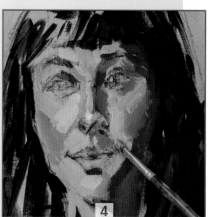

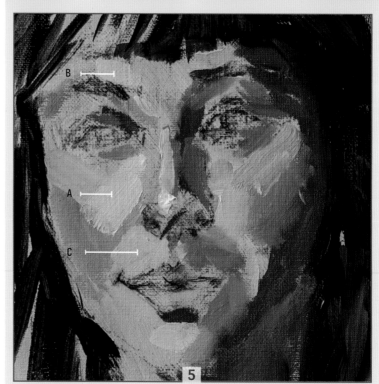

1 Add raw sienna and yellow ochre to the palette, and refresh the white. Raw sienna has a very low tinting strength, so use plenty for mixes involving this colour.

2 Create a light mix using titanium white, raw sienna and a little alizarin crimson.

3 Apply this with a size 4 filbert, painting much of the rest of the face and neck. Don't apply a uniform mix; look carefully at your model to see subtleties. For example, the cheek in shadow is slightly more pink, so use a hint more alizarin crimson here, while the cheekbone is slightly more yellow, so use more raw sienna there.

4 Compare areas with one another; the area above the lip to the cheek, for example; but keep the parts of the face in context as a whole by working from the same varied pool of paint on your palette.

5 Introduce cadmium yellow pale to your palette, and use a combination of this, alizarin crimson and titanium white to create the highlights – the lightest areas. Here, I am using it on the top of the cheek (A), above the eyebrow (B) and where the upper lip meets the nose on the side in the light (C) – our left, the model's right.

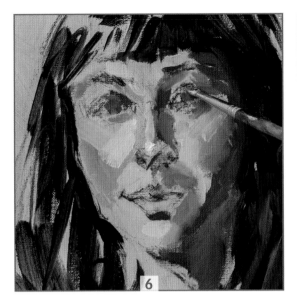

6 Start to work back into the remaining areas of blank canvas on the face, looking for areas of lighter shadows. Use combinations of the shadow and midtone mixes to paint these areas, painting with more deliberate, considered strokes. Add the eyes using ultramarine blue with a little burnt sienna.

7 The result you are looking for with these strokes should blend together when you step back, giving you definite areas that can later be blended together. This is the reason for applying the paint deliberately and quite thickly – it ensures you have enough paint on the canvas to be moved around effortlessly later. This is particularly important in the light areas.

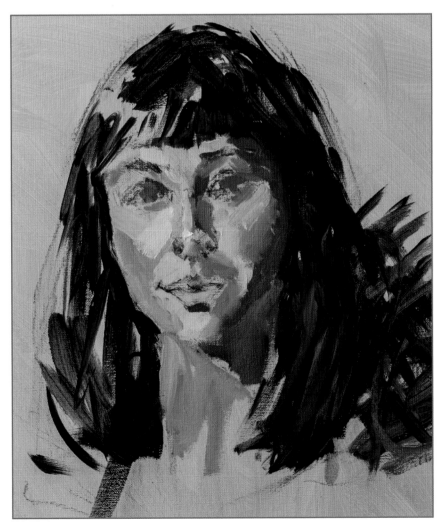

End of stage 3

STAGE 4: REFINING

Particularizing the eyes begins the finishing process which re-establishes the drawing and brings it all together. It's easy at this stage to get caught up in the portrait, but don't lose sight of the sitter. Refer to your model to get hues and values correct.

Stay positive in terms of applying the brush: don't paint for the sake of painting, or you will muddy your colours and create a half-hearted result. If you're unsure of where to apply the paint, step back and consider until you identify where to place it.

Key aims

- Apply paint thoughtfully and meaningfully
- Recreate structure where it has been lost
- Paint the mouth indistinctly.

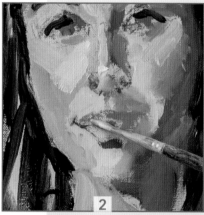
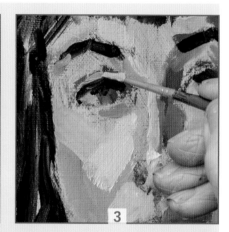
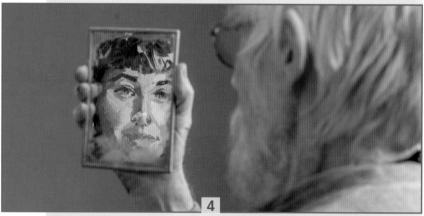
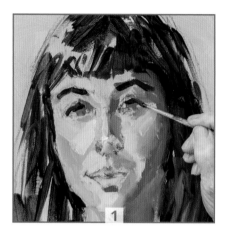

1 Re-establish the drawing with a size 2 filbert and the dark mix from earlier.

2 When re-drawing the lips, use a combination of burnt sienna and alizarin crimson, but don't be too precise here: the mouth should be painted as one, rather than as distinct upper and lower lips.

3 Switch to a size 1 round brush to continue to re-draw and refine, using the mixes already on the palette.

4 Be creative in your observation, to avoid losing sight of the overall image in the details: try looking at the sitter or painting with your peripheral vision, rather than directly; or view them using a mirror or through a camera – anything that gives you a different way of looking at them.

5 This stage is one of continuing evolution, so you mustn't be afraid of developing, re-stating or even scraping off areas to get the values correct. Here, for example, the cheek on the left of the portrait is too dark, which risks over-modelling the area (that is, creating too stark a contrast in values, which leads to too firm an edge). I therefore lighten the area.

6 When you come to areas of reflected light in shadow, such as the part that brings definition to the jawline on the right, don't fixate on the area. As your eyes adjust to the shadow, it will throw your perception of the true value out, and lead you to think you need to apply too light a tint. Instead, focus on the eyes or nose, and pick out the value of the reflected light in the jaw while doing so. Using a clean finger to gently blend the highlight brushstroke into the area will help to create a truer value, as this will naturally knock back the firmness of the edge.

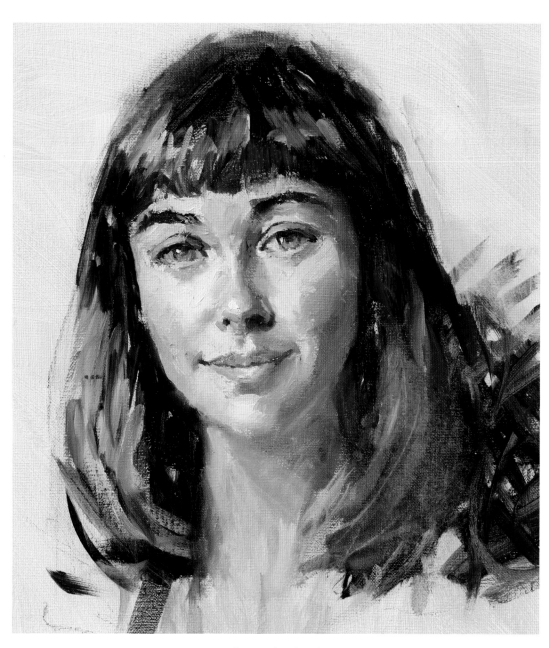

The completed study

After the study was completed, the palette looked like this – you can see the variety of skin tones and subtlety of the mixes used. The used palette also shows that I have been careful to keep the light and dark mixtures apart.

USING THE STUDY – PAINTING *FAYE*

The purpose of a preparatory study is, of course, to prepare for a complete painting. The portrait here was painted using the lessons learned from making the study on the previous pages.

This is a typical, traditional, three-quarter-length portrait with the subject posed in a relaxed manner. The emphasis was on the head and capturing the relaxed passive pose, although some strength was also given to the foreground to enhance the illusion of depth. For related reasons, the background is left slightly underdone.

When tackling a full three-quarter pose, I find having done a preparatory head study most helpful, as it allows me to confidently establish this very important part of the painting early on. I can then focus all my energy on the pose and hand positions. Not having this area resolved can start a never-ending process of working and revising, which is bound to end up as a muddy, overworked painting.

This detail shows how much of the same mixes are present in the skin shadows and hair highlights – such commonality of hue helps to ensure both read as parts of the same portrait. Note also the light on the jawline, picked out by reflected (secondary) light. Reflected lights should never be painted too light.

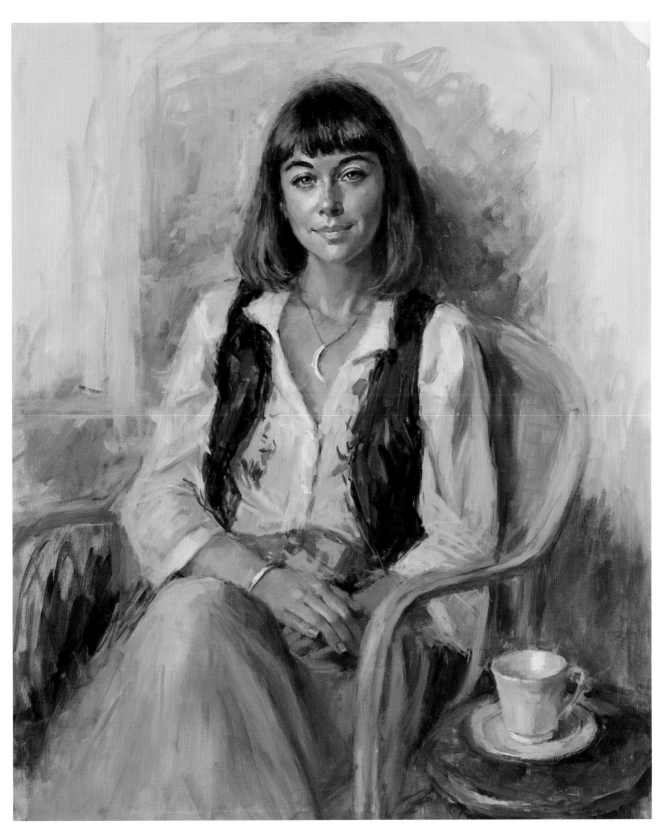

Faye 76 x 91cm (30 x 36in)

The sitting

By this time you will be ready to have a go at a full portrait painted alla prima. Make sure that you have everything at hand: the last thing you want is to stop the flow to go hunting for things. Keep your brushes – all of them – to hand, and gather up rags, paper towels and solvents. Pre-mix your medium, prepare a toned canvas and set out your charcoal, palette and paints.

Ideally, you will have a model to sit for you. If a model is not available, you must have an excellent image from which to work. The image must be large enough to see it clearly from a few steps back.

When you are ready, put on your favourite music – my own way is to put on an album that plays for about forty-five minutes – and work until it finishes before having a break. I ask my model to hold the pose for the first forty-five minutes, then do twenty-minute sessions after the break. Set yourself an overall time limit and stick to it. Three hours with breaks should be enough.

The step-by-step project presented on the following pages walks you through the main stages of direct portraiture, and is an opportunity for you to put all you have so far learned into practice. You can, of course, copy this project directly, but I hope that you will also adapt the general lessons to apply to a sitter of your own choice. Whatever your decision, I wish you the best of luck with the enjoyable and absorbing art of portraiture.

The portrait

In terms of composition, this is a traditional full-face portrait, which is ideal for portraying the expression and character of your sitter. The exact mixes of paint described here are obviously applicable only to my model, Paige, but the principles are universal. If you are using your own model, you will need to adapt the mixtures accordingly, particularly for the skin tones. The notes on pages 96–97 will help with this, but do rely on your own eye. Observation and practise will always be better than sticking to set recipes.

I like to view my paintings from a few steps back, both during the painting and at the end to make final judgements. Being too close to the canvas will make the task more difficult, so make sure you have enough space in which to work.

With regards to lighting, I carry a portable light with me so that I can have a dominant and constant light on my model. You could also position your model next to a north-facing window (if you are in the northern hemisphere – choose a south-facing window if you are in the southern hemisphere) where no direct sunlight will be coming in.

▶ You will need

Toned canvas (see page 27)
51 x 61cm (20 x 24in)

BRUSHES:

Size 10, 8, 6, 4 and 2 filberts, and size 4, 3, 2 and 1 soft filberts

PAINTS:

Ultramarine blue, burnt sienna, alizarin crimson, raw sienna, yellow ochre, cadmium red light, cadmium red, cadmium orange, cadmium yellow light, titanium white

OTHER MATERIALS:

Medium palette knife, two or three sticks of B charcoal, prepared medium (see page 25), genuine turpentine, white spirit or mineral turpentine, glass jars, rags and paper towels

STAGE 1: PREPARATION

I like to work standing up so that I can step back from my subject and canvas regularly, to appraise them together. Position your easel two metres (6ft) or so from your model and stand back so that you can see all four corners of the canvas and model. Be friendly to your model and let them know what you expect of them. Although the painting process will require your full attention, a relaxed atmosphere for both you and your model will go a long way in helping your efforts to be successful.

Key aims

- *Create a comfortable atmosphere*
- *Position the model at eye level*
- *Set the lighting correctly.*

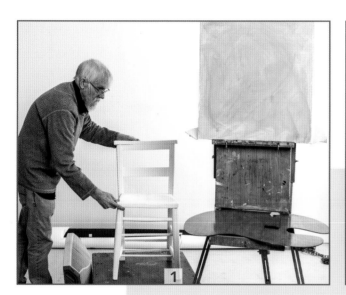

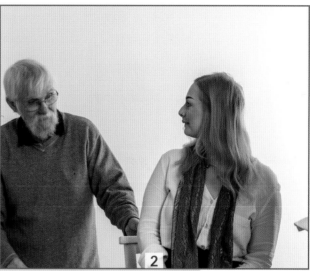

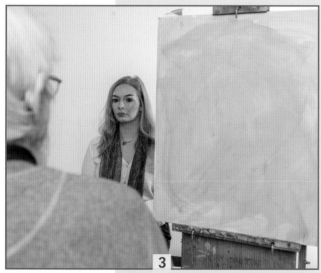

1 Get the easel and canvas arranged and set up. Arrange a chair so that the model will be sat at your eye-level – a box or model stand of sufficient height to bring the model to eye level when they are seated on a chair is ideal.

2 Greet the model and make them comfortable.

3 Check the lighting.

4 Adjust the lighting if necessary. I position the light on my model so it shows me a pleasing arrangement of light and shade. Positioning your light above and slightly to one side will usually give you the desired effect.

STAGE 2: CONSTRUCTION DRAWING

Use charcoal to create a faint linear map, which can be effortlessly adjusted until you are satisfied with the placement and size of the head. Ensure the basic proportions and important angles are correct. This gives a good starting point, but it is equally important to work broadly in the subsequent stages where the initial drawing is totally eliminated in favour of a tonal block-in.

1 Using a sharpened charcoal stick, block in the T – a horizontal line across the eyebrows, and a vertical line down the centre of the face. Extend the head shape and mass of the hair from these starting marks.

2 Use your hand span to check the starting size of the head – a handspan is roughly the same distance from chin to hairline.

3 Establish the hairline, and mark the eyebrows in more definitely. Next, check the length of nose, comparing it with the distance from hairline to eyebrow.

4 Repeat to find distance from the tip of the nose to the chin. These are the proportions of length. Use these to help you find the proportions of width. These are approximate; don't obsess about them being precise at this stage. We will refine them later.

5 Use the shadows to help find the side of the face.

6 Add one eye – this will quickly show you if the placement and overall size is correct – then use the thumb-on-stick technique to get a measurement of the size of the eye.

7 You can now use the size of the eye as a measurement to check the placement of other features, such as the nostrils. However, don't use this measurement in isolation; use it in reference to other parts of the face, such as your proportions of width and length.

8 When positioning the mouth, be aware that this subtle area is likely to be eliminated with subsequent layers of tone, so don't lock it into place too firmly.

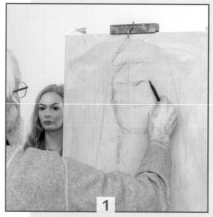

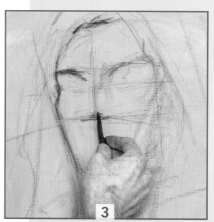

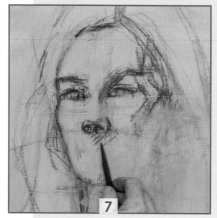

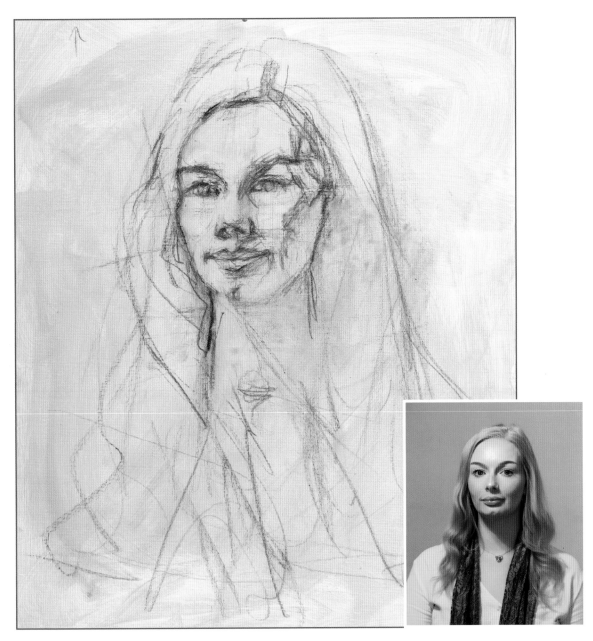

End of stage 2

This accurately shows the shadows and
lighting I was aiming to establish.

Key aims

- Get the portrait in position on
 the canvas
- Keep the portrait 'open' and
 changeable – nothing is set in
 stone at this point
- Keep the marks light.

Before moving on, hold up a mirror to the canvas
to check the drawing, then use hairspray to fix it.

STAGE 3: INITIAL PAINT

Don't overmix on your palette: allow yourself subtlety by keeping some areas nearer one or other of the component colours. Keep stepping back from the painting to check your work, and concentrate on the tones: all the detail will be refined and resolved at a later stage.

Key aims

- *Separate light and shade – these areas must complement each other, not mix into each other*
- *Keep the shadows cool, in order to better contrast with the warm light*
- *Work from dark to light, block in the underlying areas of the skin*
- *Describe the whole form of the portrait, making each brushstroke count.*

1 Lay out your paints and your prepared medium. Load a size 10 filbert with a mix of ultramarine blue and burnt sienna, diluted with genuine turpentine to a very watery consistency. Use this to block in the shadows with quick, instinctive brushstrokes.

2 For critical areas, such as the angle of the cheek, work in a slower, more considered way. Apply the paint with the blade of the brush for more control.

3 For the background, use yellow ochre and titanium white on the right-hand side, and cooler thin ultramarine blue on the left-hand side.

4 Swap to a size 1 or 2 filbert and use a mix of titanium white, cadmium red pale and cadmium yellow to paint the highlight on the tip of the nose. This point is closest to you and immediately gives a three-dimensional quality to the nose. Its position is helpful in establishing the length of nose and angle of the head more accurately.

5 Prepare a mix of burnt sienna, ultramarine blue and titanium white. Add a touch of alizarin crimson. This violet-based grey mix helps to cool the shadows of the warm skin for better contrast. Use a size 10 brush to block in the shadows.

6 Prepare a midtone of burnt sienna, alizarin crimson and titanium white and use this for the transition areas of skin between shadow and the light planes, painted thickly.

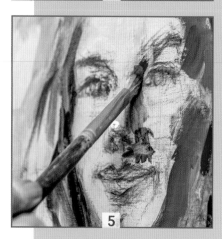

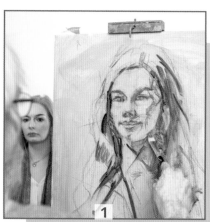

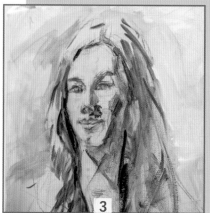

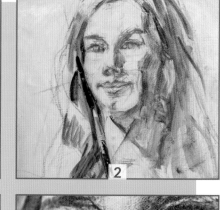

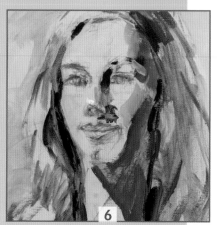

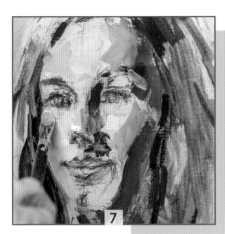
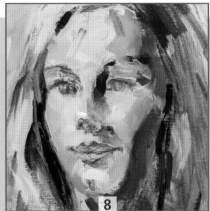
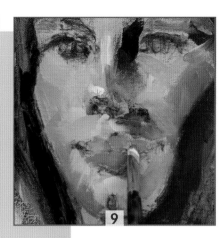

7 Switch to a slightly smaller brush – I'm using a size 8 filbert – to paint the areas of light on the skin. Introduce yellow ochre and cadmium red for the mix.

8 Use raw sienna, alizarin crimson and a touch of ultramarine blue to paint the halftone shadow areas seen on the side of the nose and upper lip.

9 Establish the lips, using a mix of cadmium red, alizarin crimson and burnt sienna. Add highlights with a mix of titanium white and raw sienna. Don't resolve the mouth – just get the overall colours right.

10 Move the easel closer, then stand back so you can make direct tonal comparisons with the model. Use the mixes on the palette to cover the underdrawing entirely. For the whites of the eyes, mix touches of cadmium orange and ultramarine blue with titanium white, and use a fine (size 1 or 2 filbert) brush to apply the paint.

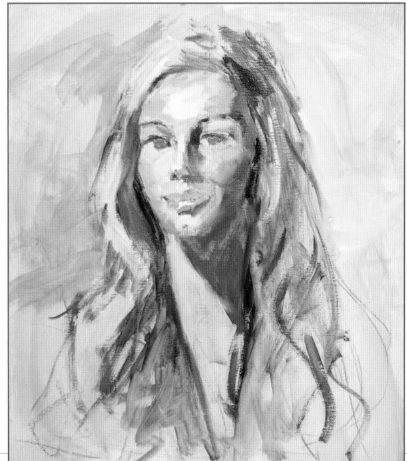

End of stage 3

STAGE 4: RE-DRAWING WITH PAINT

You have established the tones through direct comparison. Now, having covered the drawing, we need to re-establish it. Move the easel back to its initial position before starting this stage.

Key aims

- *Recover the drawing*
- *Finalize the proportions and measurements*
- *Refine the eye–nose triangle*
- *A combination of adding fine clean marks and blurring the distinction between areas of tone.*

TIP

Don't forget to ask if your sitter needs a break occasionally. When you return, make sure both you and the model get back into the same position – it's worth spending a few moments to check and adjust if necessary.

 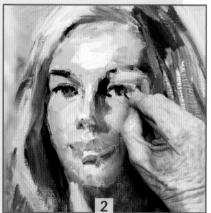

1 Use a small brush (size 1 filbert) and the dark mix of ultramarine blue and burnt sienna to strengthen important areas of the drawing. In particular, focus on the area around the eyes and nose. This is the focal point of the portrait, so placing the eyebrows and eyelids more definitely gives us an anchor.

2 Use the skin mixes on the palette to cut in finer lines across the darks – the eyelids in particular need to be brought in with fine marks. As you work, avoid becoming fixated on the area; it's important to stay aware of the area in the broader context of the portrait. Keep your peripheral vision active, to take in the mouth, hair and so forth.

3 The proportions and measurements are critical to get right at this stage, so critically evaluate your portrait, returning to the measuring techniques from earlier to double-check your work.

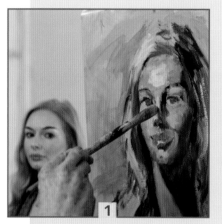

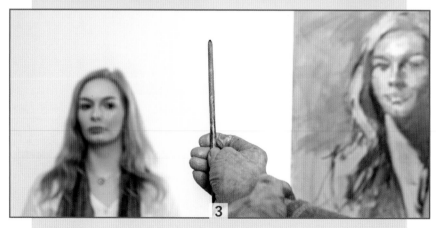

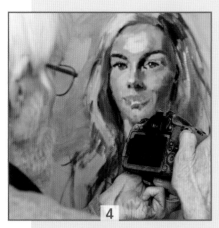

4 Taking a photograph of the painting (not your model) can help to you check you're on the right track. As with the mirror earlier, it quickly gives you a different point of view, which will highlight any areas of concern.

5 Use a mix of alizarin crimson and burnt sienna to develop the mouth. Don't overwork the mouth: too much detail here will destroy your painting. The reason for this is that we usually see the mouth in our peripheral vision, rather than directly. When we paint, we can bring too much focus to the area, which results in a mouth that is too fixed, and doesn't read well as part of the broader portrait. My advice is to try to paint the mouth while keeping your focus on the eyes.

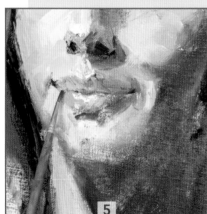

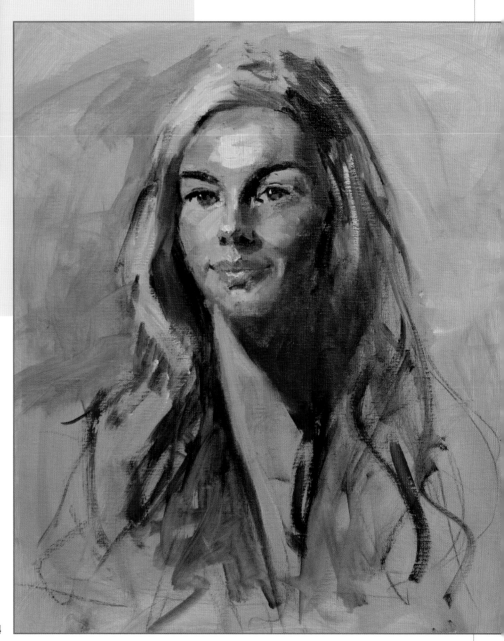

End of stage 4

STAGE 5: REFINING

Clean your palette, move the easel back alongside the model. With the features established, we now refine the other areas. I'm starting with the hair.

When refining, make constant reference to your model – keep stepping back and assessing. It's also worthwhile bearing in mind the initial marks you made, such as the proportions of length and width.

Secondly, don't over-adjust. Consider the marks you make in terms of the overall portrait and what you want to say as an artist, rather than necessarily to achieve photographic accuracy – as a metaphor, the poetry is more important than the grammar.

Key aims

- *Bring the portrait to a finished state.*
- *Take the features from 'within striking distance' to completion.*
- *Get the values and edges correct – and the hues, to a lesser extent.*

1 Being bold with every stroke, use a combination of titanium white, raw sienna and yellow ochre as the basis for the hair, with the addition of ultramarine blue for shadows. Use your thumb to softly encourage areas to blend – just make sure it's clean.

2 For the brightest highlights, apply the paint using a palette knife. Unlike a brush, this won't disturb the underlying paint, so you get the cleanest mark possible.

3 Add a hint of cadmium orange to ultramarine blue to grey it down slightly, then use this to refine the scarf. Without the neutralizing orange, the blue would be too strong, and would draw attention away from the focal area.

4 Using negative painting techniques on the background allows you to refine the edges, particularly on the hair.

5 Details like the necklace should be as simplified as much as possible in order that they don't distract from the sitter – for much the same reason as the lips aren't completely resolved, jewellery should be left as though seen in your peripheral vision.

6 In the final stage, I worked on the eye region and added reflected light to the shadows – then decided to stop before losing the freshness.

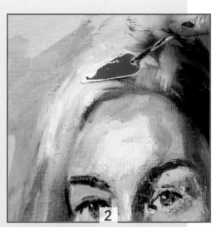

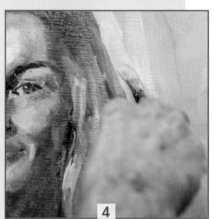

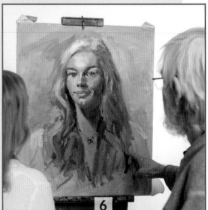

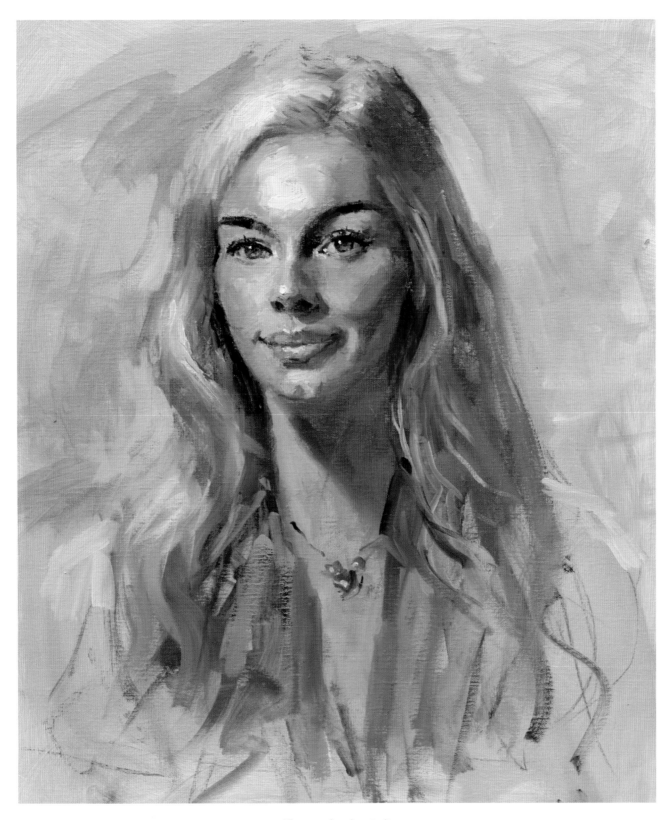

The completed portrait.

'Paintings are never finished, only abandoned.'
Leonardo da Vinci

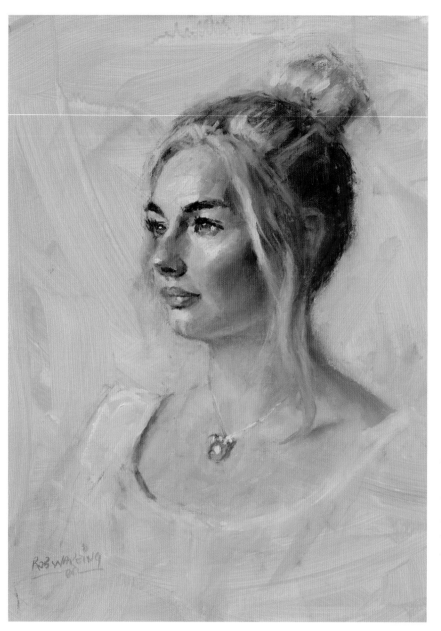

DIFFERENT SIDES OF PAIGE

In these portraits of Paige I posed her in an almost profile position under a north-facing natural light in my studio. We decided to try her hair tied up (which is a way she often wears it) to emphasize her unique features.

Experimenting with different lighting arrangements and positions can give you valuable insights on how to portray the model. Intending to complete a portrait wet-into-wet in a single sitting does not mean you shouldn't explore all the possibilities. I find the three-quarter and profile poses ideal for creating form and capturing individual physical characteristics whilst a full-face pose is better for capturing a unique expression.

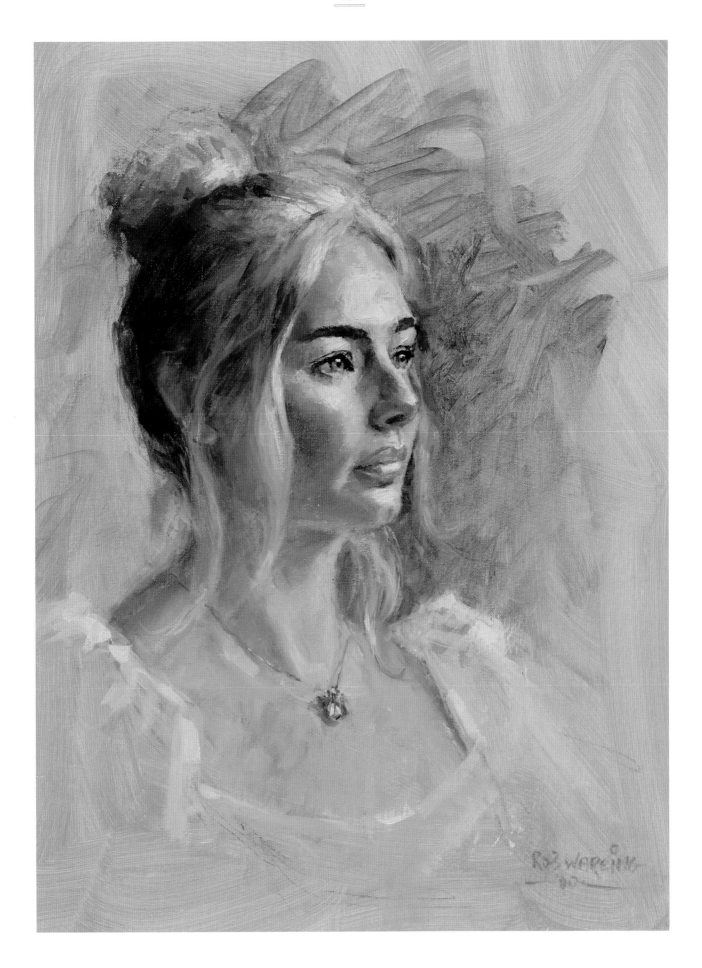

Going
further

Whether painting a commission or trying to capture the likeness of someone close to you, there are restrictions, and the pressure of trying to please not only the client but yourself can at times feel like hard work. Hence it is always a pleasure when you let go and paint someone just for yourself.

History shows us that some of the greatest work painted by past masters were paintings made purely for pleasure. I strongly recommend that you regularly allow a day to just express yourself with paint and have fun. The results might not always be brilliant but it is a certain way to help you loosen up your paintings.

BEFORE YOU START

With no one to please but yourself, prepare yourself to let go with brushes that feel too big for the task and have fun. The results will surprise you.

- Put more paint on your palette than you think you will need

- Work directly from life

- Minimize the initial drawing to just a few suggestions

- Set a time limit to complete the painting.

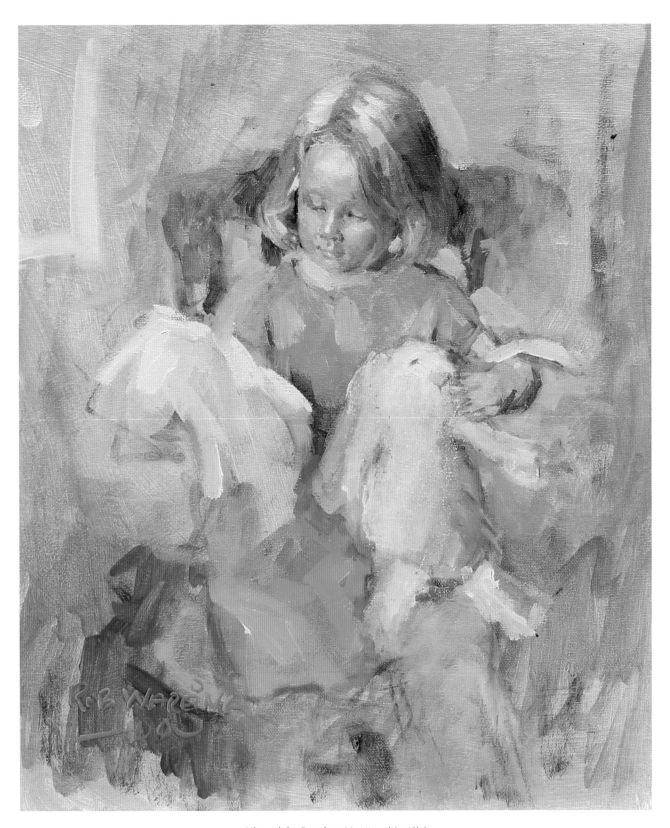

Mia and the Bunnies 30 x 41cm (12 x 16in)

Here is an example of where I just let go with no consideration of anything except
trying to put down what I saw as energetically as possible. After the session
(approximately an hour) I put the painting aside. As the subject was my granddaughter,
I felt an almost overwhelming urge to further refine the painting, which I am now
happy I resisted. Experience has taught me to be very cautious when returning to a
painting, having probably messed up more promising beginnings than most.

ABSTRACT BEGINNINGS

I usually work on a pre-prepared toned ground (see page 27), but when the subject is more complex and the design and composition more critical, I often start by doing an abstract wash rather than toning the canvas one colour.

I begin in the broadest possible manner, creating a colourful abstract and slowly hone in to the important elements. It is an enjoyable process because one keeps the painting open to endless possibilities and changes and you are not bogged down by details which could end up merely as finishing touches to an already-completed work.

Another advantage of this way of working is that right from the outset I am working on the painting as a whole and not focusing on parts. This allows me to put emphasis on the important things and play down or leave out anything which does not contribute to the painting as whole. Allowing the abstract underpainting to show through in places and stopping before over-working can also give a more contemporary look to the painting. This is also a great example of bringing order to chaos.

When starting like this I use acrylic paints, which dry quickly and become waterproof, diluted to a fluid wash consistency because I want the bright acrylic underpainting to be thin and semi-transparent. This will affect my subsequent choice of colours of oil paints to use on top of this layer. Also, the colours of this underlayer will still shine through in less opaque, selected areas. The acrylic paint colours I use for this purpose are cadmium orange, ultramarine blue, yellow ochre, cadmium red and Payne's gray. These colours are sufficient for most of the paintings I do in this way.

PAINTING *FAYE*

Faye and her partner Wren are professional musicians, so a painting of her with a guitar seemed a natural way to go. Sittings were not a problem so we spent most of the first session sorting out clothing and lighting. I completed a twenty-minute pastel sketch which showed me I was on the right track as far as colour and design were concerned.

With that complete, I quickly – almost recklessly – painted washes of colour with gay abandon over the whole of a 61 x 76cm (24 x 30in) white canvas, using acrylics and a 50mm (2in) flat brush, creating what could legitimately be called a colourful mess. You can see this on the facing page. Although this process might appear meaningless, an amazing amount has been achieved in terms of composition:

Design I can now see exactly where the head will go, and where the hands and guitar will fit so that they sit comfortably in the correct place on the canvas.

Value I have also created a middle value so that my darks and lights will register.

Space I have also got rid of the intimidating white, even canvas. As an old artist friend of mine once said, while looking at a pristine white canvas: 'How can we aesthetically improve on that?' This approach certainly helps to conquer that feeling.

Once this stage was complete and dry – being acrylic, it took just a few minutes – I quickly and loosely made the relevant sizes of head and placement of the other elements a little clearer with charcoal. I then switched to oils, still using a 50mm (2in) flat brush to working broadly over the whole canvas, to begin creating an impression of the picture as a whole.

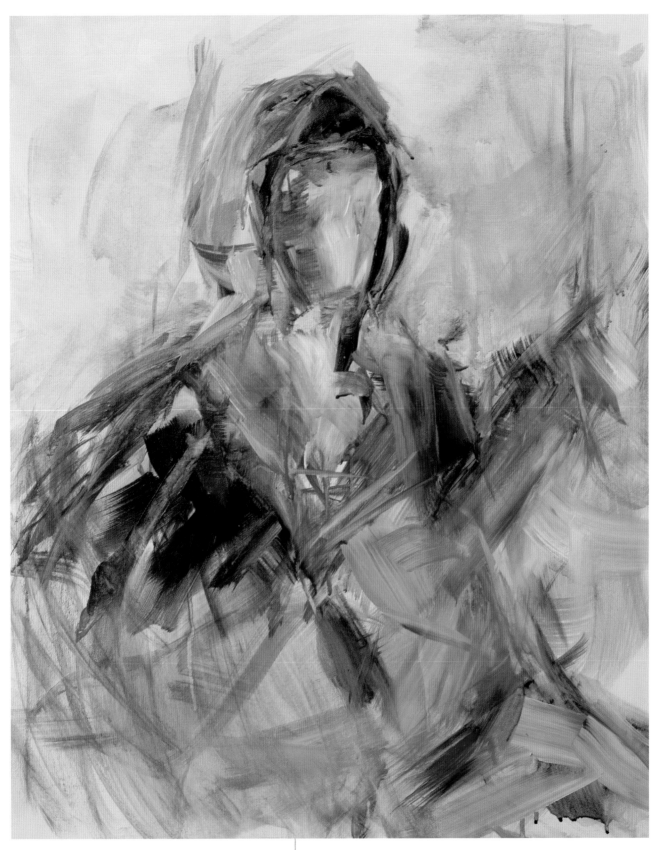

Stage 1

Abstract beginnings.

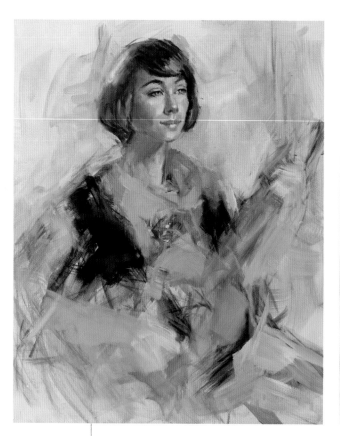

Stage 2
Creating a key section.

Stage 3
Correcting relative sizes.

I next brought the head into focus, developing it from the abstract acrylic with oils. As it is a portrait, the head is obviously the focal point and likeness and expression are important. With this mostly resolved, I had a completed key section, which helped me to decide how much finish was needed for the rest of the painting.

After correcting the relative sizes and bringing the hands and guitar more into focus, I felt that I had reached a crossroads – the picture could now easily end up having a tight, realistic finish which is not the aim of this abstract-led approach. Hence deconstructing and working broadly in the final sitting was my intention.

In the final stage of the painting, I aimed to keep some of energy of the abstract and sketch, but the necessary accuracy required for hands, face and guitar threatened to make the painting a lot tighter than I wanted. The result, however, remains close to my original intention. Once I started to feel that any more work would not improve the painting, I stopped.

Stage 4
Refining the shapes.

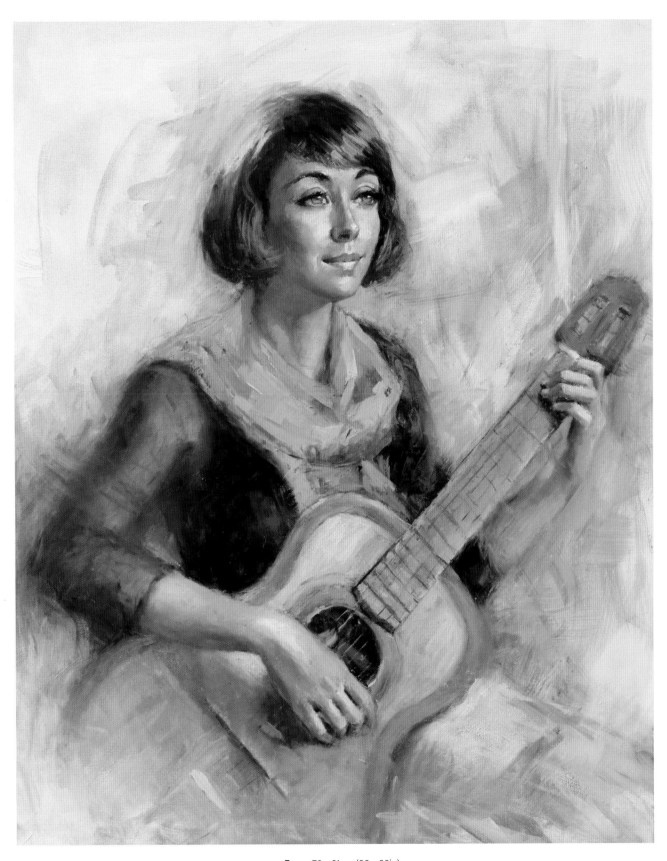

Faye 76 x 91cm (30 x 36in)

Mother and Child 61 x 76cm (24 x 30in)

SETTINGS AND BACKGROUND

The main purpose for your choice of background or setting is to enhance the portrait. It should never dominate or become more important than the focal points in your painting.

In most head-and-collar or head-and-shoulder studies, the background is either left totally unpainted – a vignette – or abstracted to subtly enhance elements in the subject which the artist wants to emphasize.

In these types of portrait, particular emphasis on the peripheral edges is important. By manipulating the background and peripheral edges, the artist guides the viewer's eye to what they consider to be important. In the painting above, note how the mother's headscarf and shoulder have been lost into the background, bringing more emphasis to the angle of her head as she leans toward the baby. Also note the edges on the baby's back going from firm to soft, then a hard edge where the buttocks change direction.

Guido 87 x 102cm (34¼ x 40in)

Most of the portraits I paint are done in this way, with very little, if any, detail put into the background. There are exceptions, of course, as in the portrait of Guido shown here. I had previously painted his family and he particularly wanted the group portrait to feature in this commission – you can see it in the background, on the wall behind him. I took a lot of care to make sure that the contrasts and edges were less prominent in the family portrait behind him in order that it stayed as part of the background. I deliberately abstracted and manipulated the family group portrait to throw greater importance on the father, who is the subject in this portrait.

Anton 51 x 60cm (20 x 24in)

Boy on the Step 32 x 38cm (12½ x 15in)

COMPOSITION AND CANVAS SIZE

HEAD AND SHOULDERS PORTRAITS

Apart from head and collar sketches, the most common portrait type you will be asked to do is the head and shoulder study, as shown to the left. Assuming you are painting a life-size (or close to life-size) head, the standard size for a portrait of this type is 51 x 61cm (20 x 24in): enough space for the portrait at life size without the result feeling either cramped or lost. Most of the portraits in this book are this size.

Depending on the model and requirements of your composition – or the client's request, if it is a commission – you might try a larger canvas. 63.5 x 76cm (25 x 30in) is an ideal size for a head and shoulder portrait if you want include a hand or two.

THREE-QUARTER PORTRAITS

The traditional size of portraits which include three-quarters of the figure is 76 x 91cm (30 x 36in). However, the size can vary, which makes them a great place to experiment with different canvas sizes. Though you might feel the need to go slightly larger, it will very seldom be smaller.

A portrait of a child with a simple background, like *Catherine*, opposite, fits well on a canvas only slightly larger than usual. A portrait of a larger person with a lot more going on in the background, however, might be better suited to a larger canvas than usual. I suggest trying 86 x 101cm (34 x 40in).

FULL-LENGTH PORTRAITS

You will seldom be asked to paint a life-size full-length portrait, mainly because you would have to allow for space in front of the figure, making it an enormous painting. I thus invariably paint these portraits smaller than life size, and less detailed than a more close-in composition.

This format is, at times, appropriate in order to capture an individual characteristic of your subject, such as the distinctive way Ben, overleaf, stands. In my own career I have found this is more likely to occur when painting children rather than adults – I find a full-length portrait looks a lot more natural with children because the emphasis on individual body language can be very appealing.

The standard sizes listed above are tried-and-tested, but there's no reason you can't experiment with different sizes. *Boy on the Step* is painted on a small canvas, but there is ample space for the whole figure along with a relatively complex background.

Catherine 66 x 91cm (30 x 36in)

When commissioned to paint Catherine I noticed an
old-fashioned rocking horse, which was a family heirloom,
in a corner of the family's sitting room. It proved to be
the ideal prop to pose her on as she found it a lot easier
to hold a pose there than sitting on a chair. I left the
background unstated to give more strength to the portrait
and foreground.

PAINTING *BEN*

Ben had a regular tendency to put his hands in his pockets and look at you with his head tilted to one side – an almost adult-like gesture, which I found appealing in a four-year-old child. I positioned him with the direct sunlight above and behind him. This meant that the direct sunlight was not in his eyes and that the majority of the face was in soft secondary diffused light (an important factor when painting a portrait outdoors). When considering where to place the figure on the canvas, I was also aware that I must leave space in front of the figure because having the feet on the bottom edge of the canvas would have looked unnatural.

After the initial sketches, I completed a pastel colour sketch, which helped me to explore colour and key (it is important when doing colour and tonal sketches not to get involved with detail). I completed the portrait in the studio – here photographs taken during my sessions with Ben were a great help in realising the original concept.

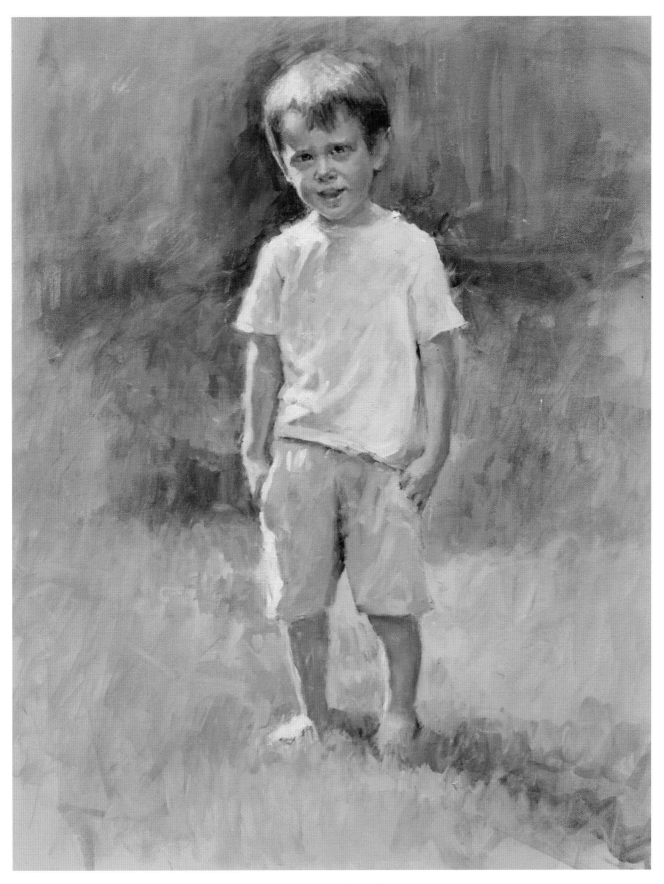

Ben 61 x 76cm (24 x 30in)

Father and Baby 51 x 61cm (20 x 24in)

Mother and Baby 55 x 75cm (21½ x 29½in)
Pastel on canson paper.

GROUP PORTRAITS

The sheer range of possibilities in painting portraits with more than one person as the subject is exciting. Apart from the traditional family grouping, such as *The Wong Family*, opposite, the subject opens the door to a number of alternative ways of painting people together.

Maternal and paternal studies, as seen above, have been popular subjects for many years. Mary Cassatt's (1844–1926) mother and child studies come immediately to mind. Other commissions I have been challenged with are family portraits within settings – such as on a beach or in a garden – where the emphasis is on the painting with the subjects as models. These are just some of the many variations associated with group portraits. They can be challenging but also a lot of fun.

The difficulty in these paintings is always to ensure that enough is seen of each individual to be recognized. Composition becomes one of the most important considerations when tackling a group portrait. The danger of too many focal points can be a real problem, as you still need to achieve convincing likenesses of each individual. My own approach is to select one of the subjects and make sure that my strongest contrasts, sharpest edges and placement on the canvas combine to make them more dominant than the other sitters.

Subtle manipulation of lighting, with the focal figure appearing to have a slightly brighter light illuminating the head, is a good way to subtly draw the focus to your selected subject. This can be seen clearly in the masterpiece *Syndics of the Drapers' Guild* (*De Staalmeesters*) by Rembrandt (1606–1669), where we are drawn into the painting to the brightly lit central figure. The fact that the figures on either side are lower in contrast, but remain making eye contact with us, helps to pull us in to the focal point without relegating them entirely to a supporting role.

The Wong Family 102 x 76cm (40 x 30in)

I raised the key of the flautist, lowering the contrasts and softening the edges to increase the feeling of her being behind the other two musicians.

PAINTING *THE REHEARSAL*

In this particular grouping of three musicians, the concept was to try to capture a moment of three young ladies rehearsing for an up-and-coming event. It was impossible to have them all in the studio together, so after scribbling in a design on the canvas to make sure they would all fit comfortably in the space, I began with painting the cellist – painting her very close to finished in a single sitting.

With this figure as a key point from which to work out the sizes and finish of the remaining two, I continued steadily on, finishing each section as I progressed and resisting the urge to go back to previously finished figures until the entire canvas was completed. The painting in the background was of my son playing the guitar which blended in with the theme.

The final stage was to look at the painting as a whole and make subtle adjustments to contrasts and edges. Photography helped me with the hands, especially with the flautist as it was an almost impossible pose to convincingly hold for any length of time.

I kept the edge of the back of the violinist's head almost lost, as a hard edge here would distract from the composition.

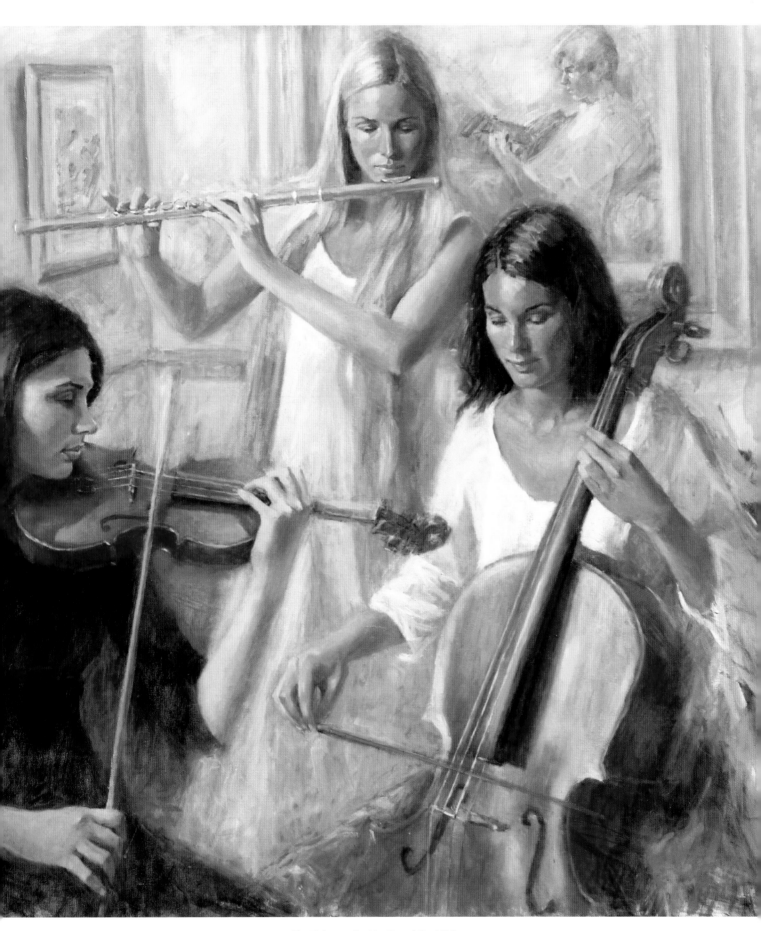

The Rehearsal 102 x 91cm (40 x 36in)

Relaxed hands

This is a detail from *Charlotte* (see page 39). In this passive pose it was important that the hands looked natural.

HANDS

When including hands in a portrait, careful consideration of their position and size is vital. Few things spoil an otherwise successful portrait than hands that appear too big or too small. Another consideration is their position. In a relaxed pose it is very easy for a hand to resemble a claw in certain positions. These negative and disturbing things seem to jump out to the viewer. Hands tend to be more convincing when they are doing something (for example, holding a pair of glasses or playing a musical instrument). I believe the reason for this is that the hands in these situations are an important part of the painting and, as artists, we give them our considered attention, whereas in the relaxed position, we may have a tendency to ignore them.

My approach to painting hands is to take time when posing the subject and make sure that the hands look natural and interesting. I try to keep the hands at different levels. My main concern in a relaxed pose is that they do not dominate. I also try to avoid any sharp edge contrasts to ensure that they remain an interesting but secondary point of interest in the painting.

Hands can be difficult, but in certain portraits they can add a tremendous amount to describing the character of a person. Capturing their gesture is a lot more important than detail. It is worth bearing in mind that they are in a constant state of motion, and even when stationary the movement of a finger can add or distract from your original intention.

When hands will be an integral part of what I want to convey I will often spend an entire sitting – that is, three hours – sketching different hand positions until I arrive at what I consider to be the most appropriate position. I will then complete a small painting of just the hands. This might seem tedious but believe me it can save hours of re-working in the final painting.

Attention to detail

Careful consideration was given to the position of the hand pressing a complicated chord.

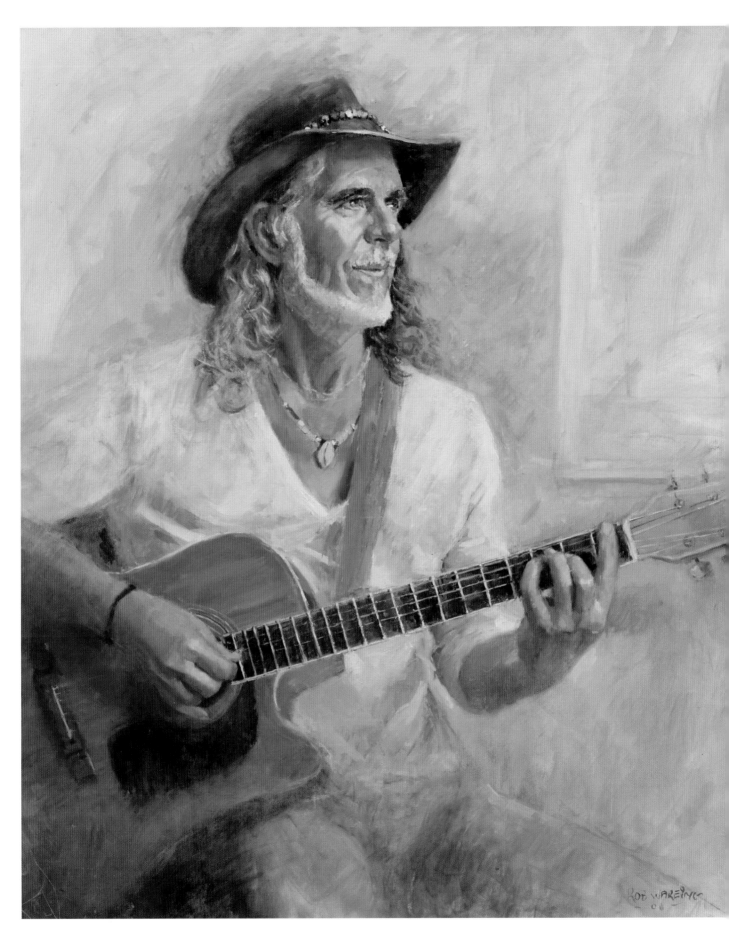

David Marks 76 x 91cm (30 x 36in)

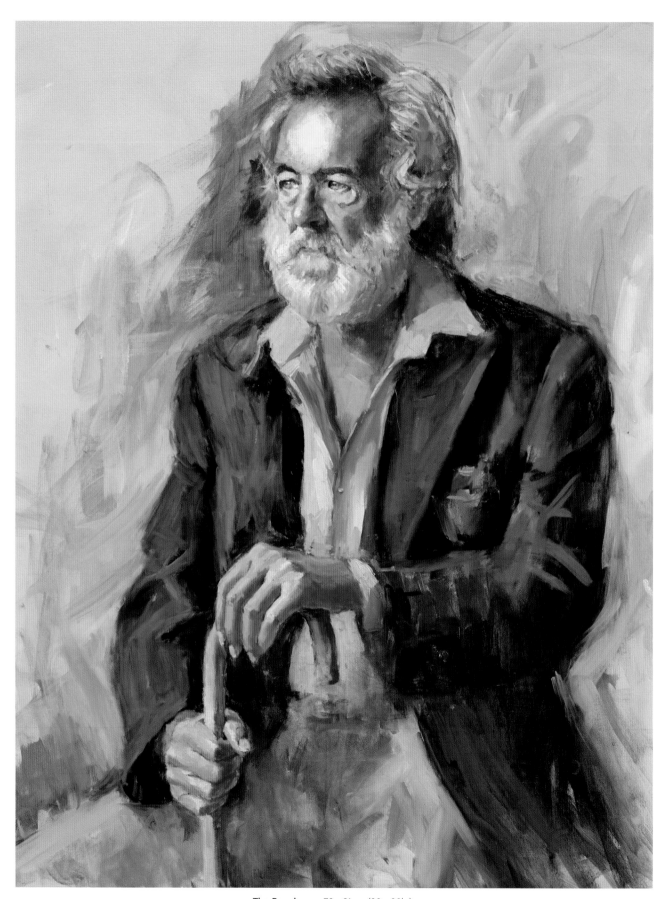

The Pensioner 76 x 91cm (30 x 36in)

PAINTING *THE PENSIONER*

The idea for this study was based on wanting to show how important hands can be in showing character. It was inspired by the countless times I have seen elderly people with walking sticks. My model was a friend whom I have painted many times before (he is, incidentally, a pensioner).

The painting illustrates how hands can play an important role in conveying character. The top hand is relaxed on the top of the walking stick, while the bottom hand firmly grips the stick in a clenched-fist position. This, coupled with the legs slightly apart and the head looking up, emphasizes the subject's masculinity.

Even though the painting was done relatively quickly, a considerable amount of time was spent sketching until I was satisfied with the design. Apart from trying different hand positions, we also tried different clothing before starting the final piece. The main reason for working in a direct manner is to retain a fresh, lively appearance to the painting with the minimum of re-working. I find doing pastel and charcoal gesture sketches and small oil studies before starting the final painting ideal for this purpose.

Rejected preliminary sketch

After a number of gestural sketches I completed this pastel sketch which I rejected, feeling the hands would be too dominant and did not convey what I wanted to capture.

Charcoal

I settled on this position. The hands were more interesting apart and I felt that the tight grip of the lower hand conveyed a certain dependency on the walking stick which suited the subject. I find charcoal ideal for this stage as I can explore angles, relative proportions and edges easily.

Tonal block-in

With a large brush I blocked in the tones, totally eliminating the drawing. Here I was looking for tonal relationships and to avoid any outlines, especially between the fingers – these I separate through subtle changes of tone, not outlines.

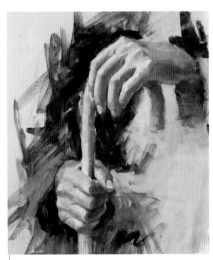

Recovery of the drawing

Here I recovered the drawing and added a little detail in selected areas. In an older person's hands the bones are more prominent, hence the knuckles and joints were important.

PORTRAITS OF CHILDREN

Of all the portraits you will be tempted to do or asked to paint, portraits of children will by far outnumber other subjects. Young children, particularly those under five years, will have you relying on your camera a lot more than you would like, for obvious reasons. However, children are a delight to paint and well worth the difficulties one is bound to encounter.

CHILDREN'S FACIAL STRUCTURE

A little understanding of how the face develops with age can help a lot, especially in capturing the correct age of the child. The irises are fully developed at birth. (This is sometimes disputed but what is accepted is that any growth in this area is minimal and for our purpose irrelevant.) It is the reason that young children appear to have large eyes.

Another important factor is the halfway point of the head. In adults, this is normally the eyes. With young children however, the halfway point is at the top of, or above, the eyebrows: the bottom half of the face becomes gradually longer as child grows older. This is the probable reason for the well-known saying 'they have lost their puppy fat'.

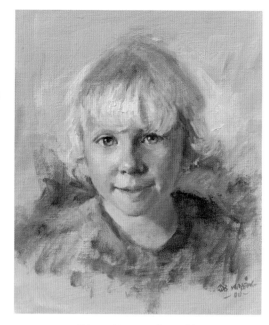

Ethan 30 x 41cm (12 x 16in)
This is a typical head study of a child.

Freya 56 x 71cm (22 x 28in)
This is an example of a larger standard portrait of a child.

PAINTING *TWINS*

When I was commissioned to paint the twins, I knew composition was going to be important. They were two beautiful girls, obviously of similar heights and appearance. Placing them at the same eye level would have led to a boring, uninspired composition. After trying several alternatives and a few pastel sketches, I solved the problem by placing one on a chair. I could now focus on their body attitude and head position. Before arriving at the final composition, there were literally thousands of poses that I discounted. I find in these situations that once you have a general idea of the design of the painting, it is important to work on one child at a time.

Before I started this painting I had completed head and shoulder pastel sketches of them, so I was reasonably sure of what I wanted to capture. The commission was for their grandparents who they were visiting at the time. They were cooperative sitters, which helped me greatly in coming up with the final design. I was aware that the hand positions were going to be important, so I spent time trying out different positions. The painting was started on location but finished in my studio with photographic references (taken during the sittings) to help me complete the painting.

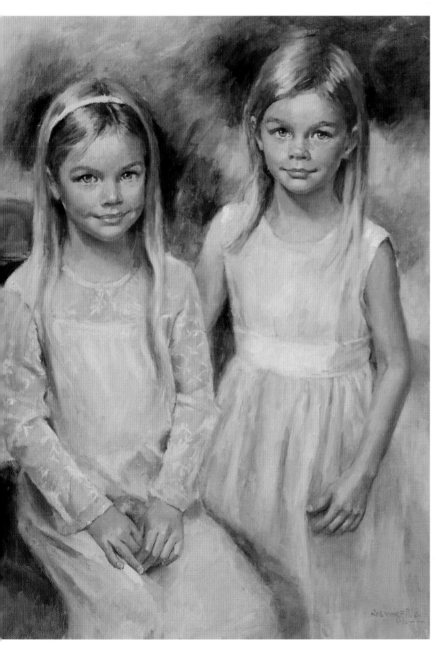

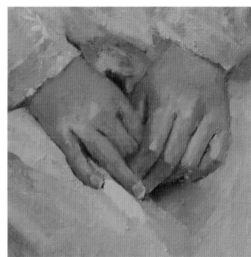

I spent a great deal of time posing and painting the hands.

Both the girls had beautiful eyes and I tried to emphasize this.

Twins 76 x 91cm (30 x 36in)

MY APPROACH TO PAINTING CHILDREN

Something seeming difficult is not an excuse to avoid having a go at it. No matter how impossible the situation appears – a hyperactive three-year-old running dangerously around your studio, for example – I always insist on a live sitting. There are times when this can be chaotic, but in most cases I have found that children sit remarkably well. I find this sitting essential as one's natural visual editing facility kicks in, and immediately helps you to identify what needs to be captured.

Photographs on their own only give one version of the person and can be very deceptive. That said, once you know what it is you want, photographs can be helpful.

Another tip when painting small children is to stay slightly aloof. Be friendly but not too friendly. The more familiar you are with them, the more they will play up. I discovered this when painting my own children and, more recently, my grandchildren.

Three on the Step 51 x 61cm (20 x 24in)

An example of a child study, typical of ones which led to my being commissioned to paint a number of children's portraits in this genre.

NATURAL POSES

More formal portraits (see *Twins* on page 153 for an example), where the emphasis is on capturing the child's likeness by accurate positioning of the features and individual expression, are traditional. Painting children at play or in a natural setting, however, can be equally rewarding and challenging.

I have received many commissions on this theme, and frequently painted my own children as models to produce paintings which expressed the joy of children in sunlight. The emphasis in these paintings is to produce a well-designed painting where the subjects are recognized more by their body language than their features.

With this approach, life sittings are much more difficult as the child is moving a lot more, but they remain an important way to get started and establish a design. Photography is a great asset for these types of painting, as you can capture fleeting moments which add charm to the painting.

Mia 51 x 61cm (20 x 24in)
An example of a child study commission where the emphasis is on the body language and not specifically on the features.

PAINTING *FOUR CHILDREN AROUND THE ROCKPOOL*

This commission, for a friend and collector, relied heavily on photography. The commission was for a large painting of my client's four grandchildren playing happily in a rockpool on the beach in front of their holiday home. Commissions like this present a lot of challenges – you must remain aware that each child has to be recognisable, which can place restrictions on the composition, for example. For reasons such as this, continual contact with the client is essential.

GETTING THE NECESSARY REFERENCES

I began with the children visiting my studio, where I made portrait sketches of each one. This allowed me to study their individual likenesses. The next stage was to set up a schedule and choose a location. We decided on the beach in front of my studio, as I was familiar with the rock pools and tides – these are big advantages. Early morning sunlight was my next requirement. Since sunshine can never be a guarantee, we set up three consecutive days when the forecast was fine. Armed with sketchbook, camera, my models and their parents, we went down to the beach.

While sketching and photographing children moving around, it is important that you stay in the same place. If you also move around while recording each individual child, you will have no chance of achieving a natural-looking composition when you place them all together in the final painting.

In this first session, while the kids were splashing around, I was scribbling and photographing, searching for a hook – that is, a point of interest from which I could start developing the design. The design really began when the two boys discovered the shell of a crab. Seeing the opportunity to use this as the focal point of the composition, I took a large number of photographs of the pair interacting. Once I was confident that I had my focal point of interest I turned my focus to the girls. With the help of their parents and my wife, we managed to get them to be part of the scene.

By the time we left the beach after the first day I had a visual image in my mind of the entire painting and the other two days were spent seeing whether I could improve on details. I then did pastel sketches and small oil gestures which I showed to my client before beginning the final painting.

Four Children Around The Rockpool 102 x 86cm (40 x 34in)

Closing thoughts

As artists, we spend an extraordinary amount of time alone – our passion to create and improve is our constant companion. Our paintings are not only a tangible record of our technical improvement but also our emotions laid bare.

In these pages I have written much about the benefits and importance of working from life, not because I believe it is the only way to do a painting, but because it is a guaranteed way to keep you enthusiastic and inspired.

My own personal journey began as an eight-year-old at a country fair, where I came across an artist doing charcoal sketches of people who sat for him. It appeared to be like magic to me, and ignited a flame which has stayed with me to this day, some sixty years later. This has made me acutely aware of how important it is to nurture the things which inspire. Passion and learning create energy and energy creates growth.

Inspiration, then, is an essential but often overlooked ingredient for any painter. If you combine inspiration with continual practice and learning, almost anything can be achieved.

Like-minded artist friends can be inspirational and I have spent many happy hours in intense discussions about drawing, values, colour and edges with good friends. The books read and re-read till the pages were worn out all inspiring us and contributing in some way to our personal growth.

My wife will confirm that I am not the most energetic person around, but in a situation where I am drawing or painting from life, I am tireless – to the extent that some people might even consider me hard-working!

Other ways to keep your fires burning: attend life drawing groups, hire a model, or paint with friends. Apart from being enjoyable experiences, they will certainly keep you inspired.

The world has changed a lot in the time I have been painting and we live in a fortunate time where access to the work of some wonderful painters is now easily accessible via the internet. This can also be helpful in deciding what direction you lean towards.

Writing this book has been both an enjoyable and at times daunting project. My heartfelt wish is that somewhere in these pages you have found some helpful suggestions and a lot of inspiration.

I leave you with one thought: Passion is everything. Why? Because without it there is nothing.

Index